A Century of Western Art

Selections from the Amon Carter Museum

BY RICK STEWART

AMON CARTER MUSEUM

Fort Worth, Texas

The Amon Carter Museum was established through the generosity of Amon G. Carter, Sr. (1879–1955) to house his collection of paintings and sculpture by Frederic Remington and Charles M. Russell; to collect, preserve, and exhibit the finest examples of American art; and to serve an educational role through exhibitions, publications, and programs devoted to the study of American art.

A Century of Western Art is made possible by a grant from the Katrine Menzing Deakins Charitable Trust, NationsBank, Trustee.

Amon Carter Museum
3501 Camp Bowie Boulevard
Fort Worth, Texas 76107-2695
Tel 817-738-1933
Fax 817-738-4066
Web www.cartermuseum.org

FRONT COVER: Wells Moses Sawyer, *Chief Joseph and Nephew [Hinmaton-Yalakit, also Hin-Ma-Toe-Ya-Lut-Kiht; or, Thunder Coming from the Water Up Over the Land, and his nephew, Amos F. Wilkinson]* (detail), 1900

TITLE PAGE: Augusto Ferran, *California Gold Hunter*, ca. 1850

COPYRIGHT PAGE: Darius Kinsey, *Ten Horses Hauling 10-Foot in Diameter Spruce Log on Skid Road in Washington* (detail), 1905

BACK COVER: Front façade of the Amon Carter Museum, © Craig Kuhner, 1996

© 1998, Amon Carter Museum
All rights reserved.

ISBN 0-88360-093-5
Library of Congress
Catalog Card Number 98-74614

Design by Russell Hassell
Printed by The Studley Press

Foreword

THE HISTORY OF THE Amon Carter Museum's famed collection of western American art began with the institution's founder, Fort Worth publisher and philanthropist Amon G. Carter, Sr. (1879–1955). Carter began his own collection in 1935, with the purchase of a painting by Frederic Remington and a small group of watercolors by Charles M. Russell. According to Carter, his interest in these two leading artists of the American West stemmed from his close friendship with the noted American humorist, Will Rogers, who had been a personal friend of Russell's. But Carter was also interested in the history of the western experience. He himself had been born in a log cabin, and he never forgot his simple upbringing and the self-reliant values he had learned as a youth.

It seems no coincidence that Carter increased his collecting activities following Rogers' tragic death in an airplane crash in 1935. He bought wisely, learning from early mistakes and actively seeking the advice of those who had firsthand knowledge of the work of Remington and Russell. By 1950 he had amassed a sizeable collection, part of which was displayed in the Fort Worth Library and elsewhere for the benefit of the public. In that year he wrote a formal letter to the Fort Worth City Council to request that a parcel of land be set aside for a future gift. "It is my purpose to erect and equip a museum and present it to the city of Fort Worth," he announced. His own collection would form the core of an institution devoted to the study of western art. To that end, Carter acquired a major private library of western Americana, forming the basis of what eventually would become a nationally recognized research library on American art.

It is unfortunate that Carter did not live to see the opening of the museum he had envisioned. The Amon Carter Museum, designed by the noted architect Philip Johnson, opened its doors to the public in January 1961, six years after its founder's death. Yet Carter would have been pleased to see his conception carried so ably forward by his family and friends. "Amon G. Carter was born and raised in a frontier community," his old friend C.R. Smith wrote in the Museum's inaugural publication. "He acquired there the habits which later brought success to his business life." For Carter, western art celebrated the heart of the American experience, and he wanted to share its lessons with others. From the beginning, the Museum's mission was to continue Carter's own high standards when it came to additional acquisitions to expand the collection. The institution's first director, Mitchell A. Wilder, stated that "Mr. Carter's personal dedication to the frontier West and the collection which he brought together have provided the incentive and the means to achieve worthy ends." But Wilder carried Carter's vision a step further by declaring that there were many different "wests" in American history, including the West of the present day. "There is no crystal clear definition of what we Americans mean by 'The West,'" he wrote just three months after the Museum's opening. "It is very close to our emotional and sentimental selves, sometimes tied in with the early yearnings for independence and self-assurance." For Wilder, a proper understanding of the American West would come through the works of art themselves, but it was important to build a collection where this might take place.

Over the intervening years the Museum's collection of art of the American West has grown from Amon G. Carter Sr.'s core collection of more than four hundred works by Remington and Russell to a wide range of holdings that number over three hundred thousand. Since 1961, the Museum has also sponsored more than one hundred special exhibitions and seventy individual publications devoted to some aspect of western art—an accomplishment that places it near the forefront of all museums devoted to the study of this area. Beyond that, the Museum has always sought to place western art in the larger context of American art and culture; indeed, the Museum practiced the concept of American Studies before the field had become fully established on its own. At the same time, new works were acquired for the collection that not only represented primary examples in the depiction of the western experience, but satisfied the highest aesthetic standards as well. The addition of photographs to the Museum's general holdings has been particularly fortuitous, for the collection now numbers thousands of images that chronicle all aspects of American life, from the 1840s to the present day.

The selection of images that follow is by no means exhaustive, but it may give the reader some idea of the incredible diversity of visual images that constitute the idea of the American West.

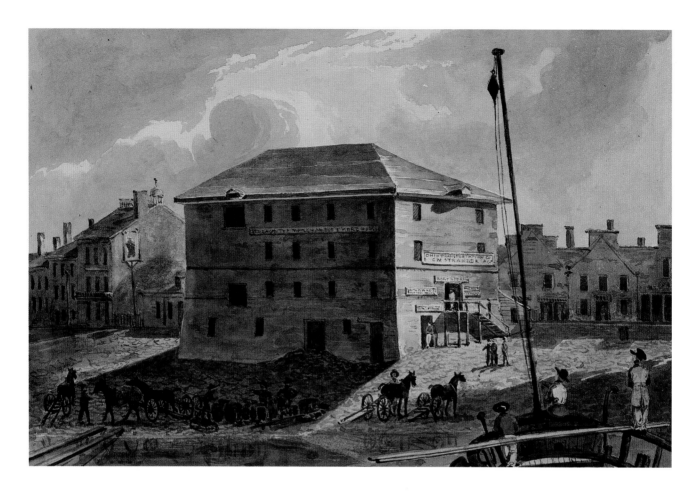

John H.B. Latrobe (1803–1891)

Louisville (Upper Landing), 1832
Watercolor with graphite underdrawing on paper
7½ × 10¼ inches (19.1 × 26 cm)
1970.51

When John Hazelhurst Boneval Latrobe visited Louisville in December 1832, the town was part of America's rapidly expanding western frontier. The Ohio River had developed into one of the country's most important transportation arteries, and Latrobe was among many travelers who recorded their impressions of the rough-edged settlements along its banks. "We arrived at Louisville soon after breakfast," Latrobe wrote in his diary, "and our boat stopped among a crowd of others at a public landing slope, paved from the top of the bank to the edge of low water, across which drags, carts, wagons, horses, men, women and children were hurrying in every direction going to and from the various vessels arriving and departing." Latrobe, who was an accomplished amateur artist, found time to explore the bustling town and record his impressions in several sketches. "The public buildings are not deficient in taste, and many of the private ones are in first-class order," he noted. During his brief stay, Latrobe managed to produce at least two watercolor studies, including this view of a storage warehouse on the riverfront, where a number of workers are preparing to transfer freight goods unloaded from the boats onto simple horse carts. Leaving aside the obvious practicality of Louisville's sloped river bank,

Latrobe thought its visual effect somewhat "singular and picturesque" for a rendering such as this.

Latrobe's father, Benjamin Henry Latrobe (1764–1820), had been a notable architect, engineer, traveler, and naturalist; among his important works were the design of the U.S. Capitol and the imposingly neoclassic Baltimore Cathedral. As peripatetic as his father, the younger Latrobe first pursued a military career before dropping out to study and practice law. Like his father, he was an inveterate traveler who often recorded his impressions in the form of drawings and sketches. His visit to Louisville occurred during a lengthy trip, immediately following his second marriage, up the Mississippi and Ohio Rivers on the steamboat *Lady Franklin.* Everywhere he traveled, he encountered fascinating frontier characters whose rough appearance and offhand manners belied a sense of "fearlessness and decision" as they went about their business of forging new societies. "These people of whom I speak are all our pioneers," he wrote at that time. "They have fought with the wilderness and overcome it, and if they have lost the polish of society. . . they have added a portion, and a goodly portion, to the great country which is the pride and hope of the free spirits of the world."

Richard G. A. Levinge (1811–1884)

The Paddle Steamer "Ouishita" on the Red River, Louisiana Territory, ca. 1836

Watercolor with gum arabic glazes on paper
8⅜ × 12½ inches (21.3 × 31.8 cm)
1968.271

In 1836 Levinge, a young British Army officer stationed in Canada, made an adventurous trip down the Ohio, Mississippi, and Red Rivers as far as present-day Alexandria, Louisiana. Eventually returning to England, he published an account of his travels as *Echoes from the Backwoods; or, Sketches of Transatlantic Life* (1846), which was accompanied by his own illustrations. In the book Levinge described boarding the steamer *Ouishita* at the mouth of the "sullen, sluggish, red-ochre-coloured" Red River to travel northwestward to Alexandria. The river was swollen in places, and Levinge noted that "on every log or uncovered bank lay numbers of alligators; we fired with our rifles at many of them, and, although close to them, the ball had no effect except in the instance of a very small one which a Yankee killed." He also stated that "quantities of beautiful egret, or lesser egret, together with rose-coloured spoonbills, also appeared on the banks."

During Levinge's travels ever westward, progress was often complicated. "The Red River is the highway to Texas," the British artist-traveler reported, "but the navigation is stopped some sixty miles above its union with the Mississippi by an enormous raft of cedar, which, having drifted down the river for centuries, lies in masses of huge trees, one over another, and extends for many miles." They nevertheless made their way to Alexandria, a settlement so wild that the inhabitants were said to have run a clergyman out of town for attempting to establish a church. "The ruffians who composed the invading army to Texas were at this time passing up the Red River," Levinge noted. "Sundry hints were given to us, that the reality of our being British officers travelling for amusement was questioned, and that we were suspected of being spies. In consequence, we abandoned a hunting expedition already planned, took the hint, and prepared to cross the prairies of Louisiana towards New Orleans." Despite Levinge's protestations of innocence, there were instances where British Army personnel did indeed impersonate tourists for the purposes of gathering information concerning American interests on different parts of the expanding frontier.

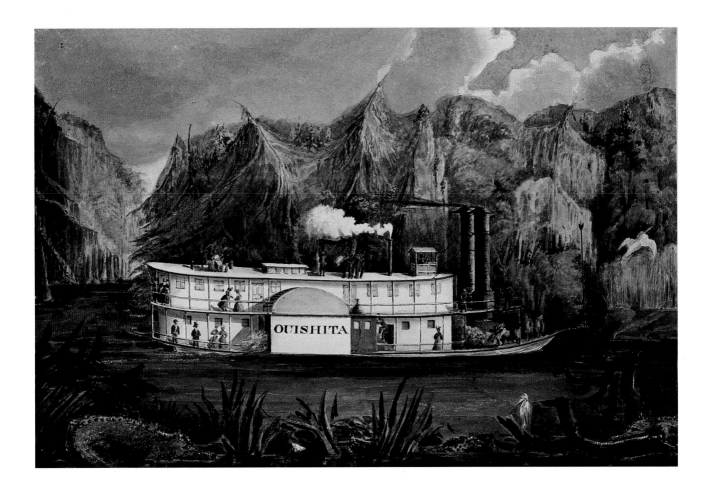

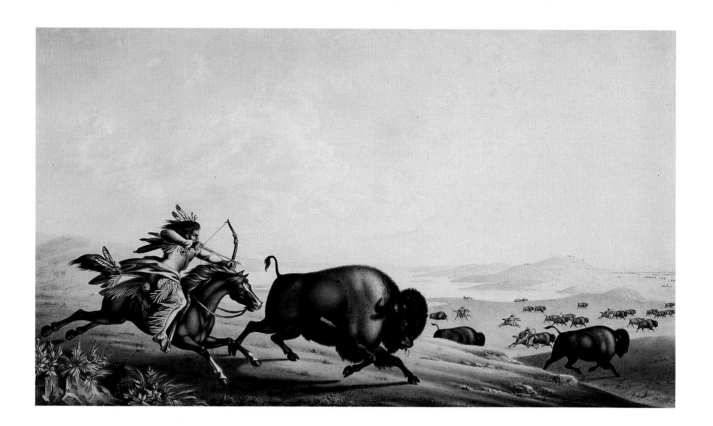

Peter Rindisbacher (1806–1834)

Assiniboine Hunting on Horseback, 1833
Watercolor with glazing on graphite underdrawing
9 × 16⅛ inches (22.9 × 41 cm)
1966.50

Although he had a tragically brief career, Rindisbacher created some of the earliest and most striking images of life on the northern prairies. Born and trained in Switzerland, the young artist immigrated with his family in 1821 to the stark plains of southern Manitoba to become a part of Lord Selkirk's struggling Red River Colony south of Lake Winnipeg. Over the next several years, often amidst extreme hardships, Rindisbacher employed his talents as a miniaturist to create scenes of austere beauty and meticulous realism. On the Red River in Canada and along the Upper Mississippi as far south as Illinois, he portrayed native peoples such as the Cree, Ojibwa, Assiniboine, Lakota, Winnebago, Sauk and Fox, along with Métis and white fur traders. After he moved to St. Louis in 1829, Rindisbacher began to receive wider notice for his depictions of life on the prairies, but he died suddenly in August 1834, possibly from the deleterious effects of cholera. As the *Missouri Republican* sadly noted in its obituary, the young artist "had talents which gave every assurance of future celebrity."

On the northern Plains Rindisbacher had the opportunity to witness a number of buffalo hunts, for the animal was critical for the survival of native and settler alike. He was in the habit of making careful sketches of his subjects in graphite, then recopying them in watercolor to adjust details or make more substantial changes in composition. This highly finished watercolor probably depicts an Assiniboine hunter preparing to deliver a final arrow to a fleeing bison, which has already been mortally wounded. The warrior's long hair is an Assiniboine characteristic, for the males of the tribe often added false hair to make the twists reach to the ground. Hunting the buffalo was a chief occupation of the tribe, because they processed the meat into pemmican for barter to the white traders and settlers in the region. Rindisbacher's astonishingly microscopic brushwork—some of his brushes only had a few hairs—makes the surface of the watercolor appear as if it had been airbrushed. "Each hair on a bison or deer or otter or dog appears to be individually shaded and seems to glow," wrote an admiring critic more than thirty years after the artist's death. "The melting of soaring clouds in the landscapes, the transparent air and distances, the swelling of the earth, the charm of plant life, the desolateness of snow—all is pure depiction of nature whom he chose for his one and only teacher."

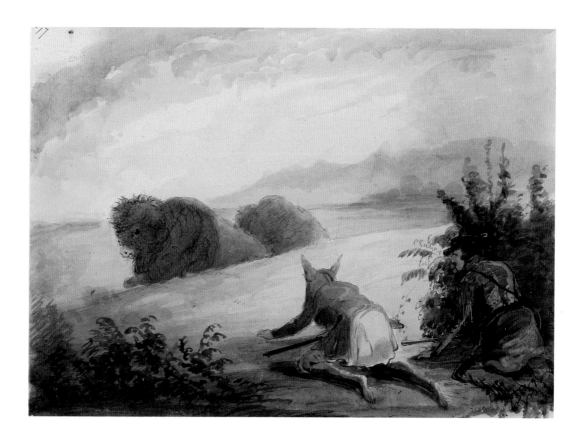

Alfred Jacob Miller (1810–1874)

Approaching Buffalo Under the Disguise of a Wolf, ca. 1837

Watercolor, gouache, pen and ink with gum arabic glazes on paperboard

6 ⅛ × 8 ½ inches (15.6 × 21.6 cm)

1966.26

Miller was a Baltimore painter who had studied in Paris and Rome before he was hired in 1837 to serve as the artist for a "grand safari" to the Rocky Mountains. Miller's patron and employer for this trip was William Drummond Stewart, a Scottish nobleman, adventurer, sportsman, and veteran of the Napoleonic Wars. The party embarked from Saint Louis and followed much of what would later become the route of the Oregon Trail as far as the Green River country of Wyoming. Miller thus became one of the first artists to enter the Rocky Mountains, and the only one to depict scenes involving the rapidly disappearing fur trade. The 1837 fur traders' rendezvous, which the artist witnessed, was one of the last of its kind to be held. Due to the necessity of traveling light, Miller created drawings and watercolor studies in sketchbooks and on small sheets of paper. Upon returning to his studio, he worked the field studies up into more finished watercolors and paintings, some of which were produced for his patron Captain Stewart's home in Scotland, Murthly Castle.

Unlike some of his artistic contemporaries, Miller was captivated by a romantic sensibility, and his works echo the exotic spirit of the French painter Eugène Delacroix (1798–1863),

whom he greatly admired. While traveling with the expedition, Miller had ample occasion to witness the hunting of the buffalo. Captain Stewart also employed the services of Antoine Clement, a skilled hunter and guide who was part Cree Indian. In this watercolor, Clement takes advantage of the buffalo's notoriously poor eyesight to creep slowly up to them on all fours. "The hunters form for themselves a peculiar kind of cap," Miller wrote in his notes on his sketches. "It has two ears with a flap reaching to the shoulders. This is worn with a double object in view, one of which is to deceive the buffalo in approaching; under such guise the hunter is mistaken by the animal for a wolf, and is suffered to advance quite near. The mop of hair covering the forehead of the buffalo obscures his sight and aids the trapper in his deception." Captain Stewart, whom the artist always depicted with a somewhat oversized nose, watches from the safety of some bushes. The animals were not bothered by an individual wolf skulking around the herd, so Clement is being allowed to approach. As soon as he gets within range, he will fire a fatal bullet into the beast. The buffalo's sense of smell is very good, so such subterfuge had to take place where the hunters were "out of the wind" of the ruminating animals.

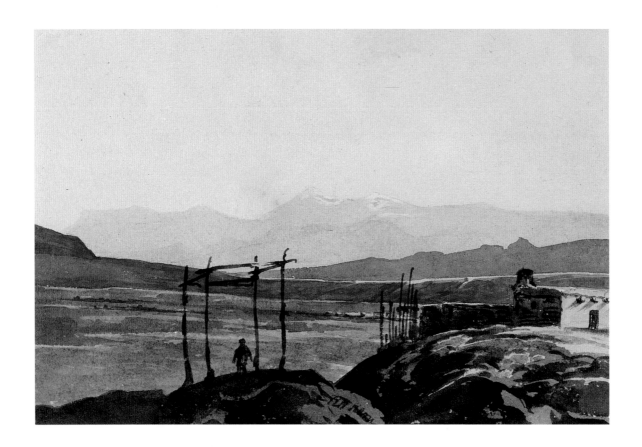

Richard H. Kern (1821–1853)

Valley of Taos, Looking South, N.M., 1849
Watercolor and graphite underdrawing on paper
3 ⅞ × 5 ¾ inches (9.8 × 14.6 cm)
1975.16.6

For many artists, the American West was a grand arena for adventure and discovery; for Richard Kern, it was also a setting for tragedy. In the fall of 1848 he and two of his brothers, Edward and Benjamin, traveled west as members of John C. Frémont's ill-fated fourth expedition into the San Juan Mountains of southern Colorado. Kern and his brothers barely survived their harrowing ordeal, arriving in the Taos Valley sick and debilitated in February 1849. It was probably during their period of recovery that Kern executed this watercolor of the Taos Valley, with the dangerous snows that had almost killed them still clinging to the distant mountaintops. This beautifully quiet view, showing the pristine locale that would later draw legions of tourists, belies the dangers that Kern and his brothers still faced. In March of that year, Benjamin Kern was killed by Indians as he journeyed up the Rio Grande in an attempt to retrieve some of the equipment the men had been forced to leave behind after the failure of the Frémont expedition.

Kern had studied art in his native Philadelphia, and he and his brothers had operated a school and studio there, where they produced works for the scientific community. It was this interest which induced them to go west, and their depictions of New Mexico are among the earliest and most important visual records of the region that have survived. The death of Kern's older brother caused him to remain in the Taos area, becoming one of the first artists to explore and sketch some of the notable features of the surrounding country. Soon, he was employed by Lieutenant James H. Simpson of the U.S. Army Corps of Topographical Engineers to provide views of a number of important sites from the various Indian pueblos near Santa Fe to the notable features that extended westward into the Navajo country; more than sixty of Kern's illustrations were published in Simpson's official report in 1850. Kern then participated in a number of important expeditions led by the Army Topographical Engineers; but in October 1853, his own luck ran out. He and Captain John W. Gunnison were among those killed in a surprise attack by Pahvant (Ute) Indians near Sevier Lake in western Utah. Kern was justly eulogized by his friends as an "eminent artist" and a "martyr to physical science."

Henry James Warre (1819–1898)

Indian Grave near the Entrance of the Columbia River. N.W. Coast of America., 1845

Watercolor and graphite underdrawing on paper
7 1/16 × 10 1/4 inches (17.9 × 26 cm)
1996.4.12

In the spring of 1845 there was much tension between the United States and Great Britain over the question of the Oregon country and the location of the international boundary west of the Rocky Mountains. Lieutenant Warre, an aide-de-camp to the commander of the British Army forces in Canada, was ordered to travel to the Oregon country and investigate the strength of American interests there, in the event the two countries came to blows over the territory. Under the guise of a "gentleman of means," Warre traveled overland through Canada and down the Columbia River, reaching Fort Vancouver at the end of the summer. He spent the next few months visiting the American settlements on the Columbia and Willamette Rivers, producing a series of remarkably precise watercolors that reflected his growing admiration for the Oregon landscape and increasing realization that the American presence was too great for the British to counteract. By the time Lieutenant Warre had returned to eastern Canada to report to his superiors, a diplomatic resolution of the Oregon boundary already had been reached.

Warre's watercolors remain among the most important views of the Oregon country produced in the early frontier period. His renderings of Native American subjects, such as these Chinookian canoe burials on the lower Columbia River, depict customs that were already rapidly disappearing when he witnessed them. Forty years earlier, the explorers Meriwether Lewis and William Clark had noted these distinctive burials all along the lower reaches of the river. In his journal Clark described the vertical placement of four cedar planks, their flat sides facing each other, joined by mortised members that supported the canoe in an elevated position. The body of the deceased was laid within, wrapped in a robe of dressed skins and protected with rush mats and cedar boards. Clark also mentioned the various articles of clothing and utensils that were frequently hung or arranged about the canoe, which can be clearly seen in Warre's carefully executed watercolor. Shortly after Warre's visit, with the sudden influx of American settlers into the Oregon country, Native American sites such as these canoe burials had all but disappeared.

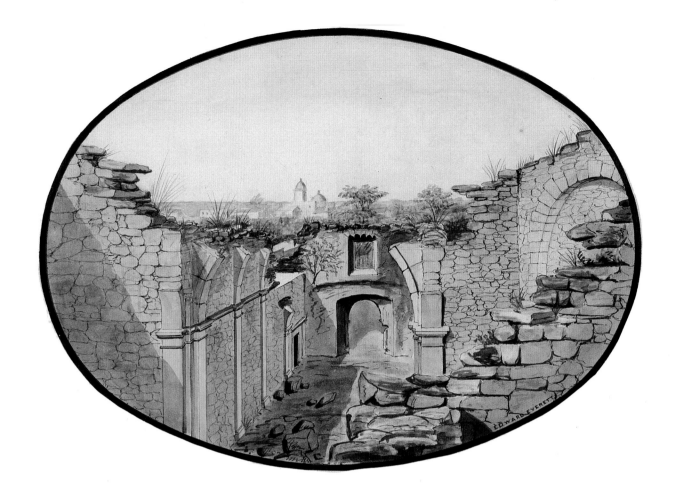

Edward Everett (1818–after 1900)

Interior View of the Church of the Alamo, 1847

Watercolor, gouache, ink, and graphite on paper
5½ × 7⅝ inches (14 × 19.4 cm)
Gift of Mrs. Anne Burnett Tandy in memory of her father
Thomas Loyd Burnett, 1870–1938
1977.8

The Alamo is so obscured by an aura of patriotic symbolism and historical myth that it is difficult to imagine it as a particular place. In 1847, a little over ten years after it served as the backdrop for one of the most important events in Texas history, the ruined church of San Antonio de Valero—known today as the Alamo—was sketched by Edward Everett, a member of the Illinois Riflemen dispatched to Texas to serve in the Mexican War. Everett had arrived with his unit the preceding August, and due to his ability as an artist he was given orders to gather information on the history and customs of the area, which included "making drawings of buildings and objects of interest." A serious injury caused Everett to remain in San Antonio, where he continued to make careful sketches of a number of local subjects. One of these was the ruined Alamo, which the U.S. Army planned to renovate for offices and as a depot for military stores.

Because these renovations were completed within a few years, Everett's depictions of the Alamo remain among the earliest and most accurate ever created. This view of the interior,

probably taken from atop the north wall of the sanctuary, looks westward through the crumbled nave and over the front of the broken façade. Beyond, one sees a few houses and the round domes of San Fernando Church in the distance. Everett employed an oval format to focus his carefully wrought composition, and as befits his training as an engineer he employed a straightedge and compass to mark off the surviving architectural elements of the interior. His skills as a watercolorist can be seen in the careful shading of the stonework and highlights conveyed by the white of the underlying paper. By 1851 the renovation work on the structure—including a new roof and the present scroll-top façade—was virtually complete. Everett described the compound as accommodating officers' quarters and storage rooms for ordnance and medical supplies, as well as areas of activity for blacksmiths, harness makers, carpenters, and wagon makers. But interestingly, he thought the new scroll-top design of the façade "ridiculous," because it gave the appearance of "the headboard of a bedstead."

Friedrich Richard Petri (1824–1857)

Plains Indian Family on Horse—and Muleback, ca. 1852–57

Watercolor, gouache, and graphite on paper
7¼ × 6⅞ inches (18.4 × 17.5 cm)
1988.34

Between 1844 and 1847 an organization called the Society for the Protection of German Immigrants in Texas managed to bring more than seven thousand Germans to Texas, establishing such communities as New Braunfels, Fredericksburg, and many other smaller settlements. The failure of the Revolution of 1848 in Germany led to increased immigration to Texas, and the Dresden-born artist Richard Petri was among those who sought a new life there. By 1852 Petri and his brother-in-law, the artist Hermann Lungkwitz, had settled with their families on a parcel of land near Fredericksburg. Both men worked hard at farming, but they also found the time to depict their surroundings in a number of drawings, watercolors, and paintings. Petri grew fascinated with the Lipan Apache and Penateka Comanche Indians that visited them, though like most settlers he frequently complained to local authorities about their alleged depredations on his farmstead.

Petri had received rigorous training at the Academy of Fine Arts in Dresden, and he utilized his finely tuned artistic skills to depict the native peoples of central Texas. This sketch of a Lipan or Comanche family is typical of the type of quick field study that Petri produced while observing the life of the Indians around him. He captured the distinctive features, vivid face paint, and notable dress that must have seemed vibrantly exotic to his Old-World eyes. The brave on horseback wears a hair-pipe breastplate with an ornate silver gorget, and a queue of his long dark hair is adorned with a row of silver conchas. As Petri shows here, both Lipans and Comanches carried steel- or iron-tipped lances that averaged more than seven feet in length; although these were regarded as formidable weapons, the bow and arrow was more commonly used. Petri often repeated poses and motifs in his sketches as he reworked them into more elaborate images; the woman shielding her eyes can be found in other drawings he created in the period. Although Petri seems to have been actively involved in making his family's farm a success, he was dogged by lung ailments and generally weak health. In December 1857, while seeking respite from a bout of fever and sickness, Petri drowned in the Pedernales River.

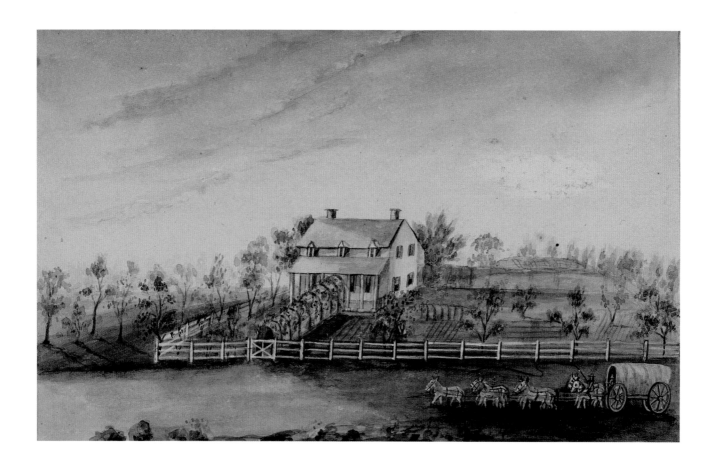

Sarah Ann Lillie Hardinge Daniels (1824–1913)

Residence of Col. Ths. Wm. Ward. Austin-Texas., 1852
Watercolor, gouache, and graphite underdrawing on paper
6 × 9½ inches (15.2 × 24.1 cm)
Gift of Mrs. Natalie K. Shastid
1984.3.15

There are few women among the artists who portrayed the American West in the first decades of its development; individuals like Sarah Ann Lillie Hardinge were truly exceptional. The youngest of nineteen children, she was raised in Boston and fell heir to a parcel of land in Texas that had been acquired by a brother. She arrived in Galveston, Texas, with her husband in February 1852 and proceeded to Houston where she met Thomas William "Peg Leg" Ward, a veteran of the Texas Revolution and mayor of the small village of Austin. Poor traveling conditions led the Hardinges to accept Ward's generous offer of a ride in his own carriage, and they journeyed together to Austin. There Sarah Hardinge accepted Ward's invitation to stay at his house while her husband traveled on to Matagorda to pursue the matter of her brother's land claim.

Sarah Hardinge was a self-taught artist, and during her brief stay in Texas she created a number of carefully wrought watercolor views of her surroundings. This view of the Ward house in Austin, where she spent her initial days as a guest, is regarded as her first depiction of the region. The handsome house, designed by the noted early architect Abner H. Cook, once stood at the southwest corner of Hickory (now Eighth) and Lavaca Streets. Hardinge's precisely rendered watercolor shows a simple foursquare house with a columned front porch in the Southern style, surrounded by painted fences and well-kept gardens and orchards. An arched rose arbor extends the length of the walkway from the front gate to the front porch steps, and a screened verandah may be discerned at the rear of the house. Although much of Texas was still contested frontier, the Ward house must have seemed not only a cultural oasis to Sarah Hardinge, but a promise of similar hopes for her own situation. Sadly, such prosperity was not to be. Within a few years her husband had dissipated their chances of any opportunities for advancement, and the couple was forced to return to Boston. In the end, Sarah Hardinge must have harbored mixed feelings about the promises of the American frontier. Despite this, she left a precious legacy in a journal and numerous evocative watercolor depictions of settled areas in and around Pleasant Grove, Seguin, and San Antonio, Texas, in the middle 1850s.

Henry S. Sindall [attributed] (active 1850–1860)

Camels Crossing a Western River, ca. 1860
Watercolor and gouache with gum arabic glazes on paper
10⅛ × 15¼ inches (25.7 × 38.7 cm)
Gift of J.N. Bartfield
1973.1

In 1856 one of the stranger occurrences in the history of the American West occurred when the United States War Department began testing camels for possible use on southwestern trails. After establishing quarters for them at Camp Verde near Bandera Pass in Texas, the animals proved successful in transporting goods to regional locations. "The usefulness of the camel in this interior country is no longer a question," reported Major Henry C. Wayne, the officer in charge of the camel contingent, to his superiors in Washington. In June 1857, further experiments were undertaken when a train of mule-drawn wagons and twenty-five pack camels under the command of Lieutenant Edward Fitzgerald Beale left San Antonio for California on an exploring expedition for the Corps of Topographical Engineers. The expedition journeyed to Fort Davis and El Paso, then up the Rio Grande toward Fort Defiance in western New Mexico, where they had been assigned to perform a survey of a new wagon road as far as the Colorado River.

Little is known of Henry S. Sindall, but he produced interesting depictions of scenes in West Texas in the late 1850s, all executed in a meticulous, though somewhat naïve style. This watercolor of mule-drawn wagons and camels crossing a river has been attributed to him based on its similarity to other works known to be by his hand. Some historians now believe that Sindall may have been associated with U.S. Army units commanded by Captain John Pope that were drilling for sources of artesian waters in various parts of West Texas and New Mexico during the same period. Although it is known that Beale's caravan encountered Pope's crews on at least one occasion, there are other instances in the same period where other camel forays were undertaken in Texas, particularly two that journeyed from San Antonio to Fort Davis and the Upper Rio Grande country in 1859 and 1860. Perhaps Sindall executed his watercolor as an eyewitness to one of these, or through informed sources; at any rate, the thickly wooded, limestone-bedded river in his watercolor bears a strong resemblance to several Texas waterways.

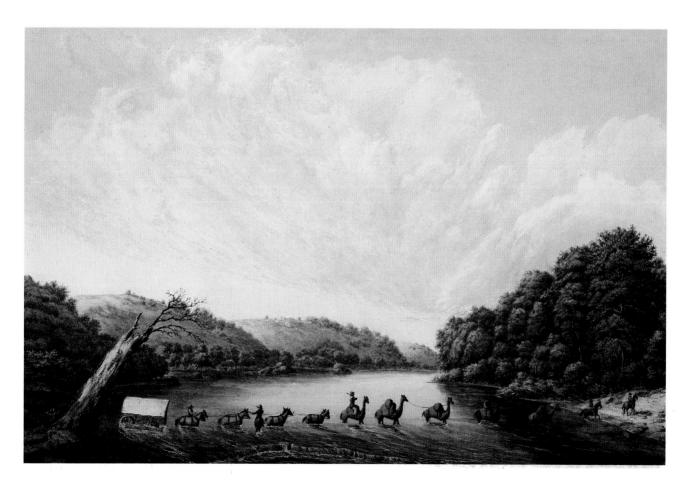

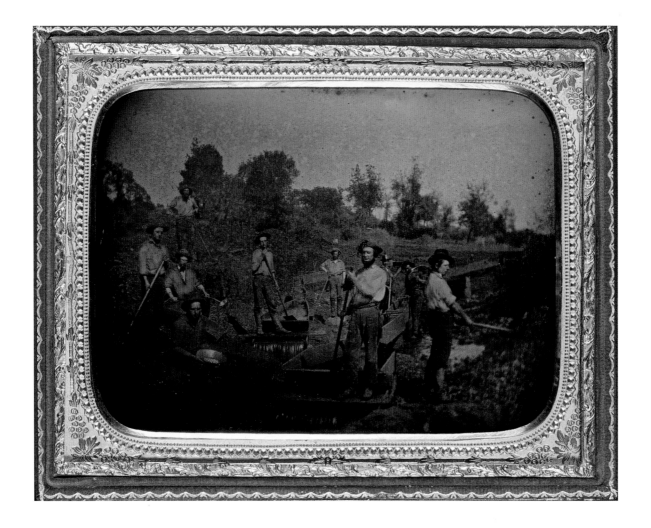

Artist Unknown

[Gold mining scene], ca. 1850s
Ambrotype
3⁷⁄₁₆ × 4¾ inches (8.7 × 12.1 cm)
P1981.88

This photograph marks two transformative events in the history of the American West: the discovery of gold in California that resulted in a mass exodus of emigrants westward, and the rise of photography as a powerful instrument to record the sweeping changes that would forever alter the western lands. In the early 1850s, photographers joined the mass exodus to the California gold fields to share the promises of opportunity. While some of them may have actually tried their luck with pick and shovel, others used their skills and equipment to record the exciting scenes around them. Thousands of erstwhile fortune seekers wrote hopeful letters to family members back home, and it is likely that some of them commissioned photographs such as this one to document their activities on their claims. At the same time, other pioneering photographers, such as S.S. McIntyre and Robert H. Vance, exhibited their daguerreotypes of the gold fields to curious and enthusiastic audiences in New York City.

This small ambrotype, by an anonymous photographer, shows ten men posed in the sunlight amidst meandering sluice chutes along a California stream. The seated man in the left foreground holds a miner's pan to which the enterprising photographer has obligingly added a bit of gold color—perhaps to encourage the viewer that profitable results were close at hand! Since there was a strong demand back East for photographs of the gold fields, one may surmise that such "doctored" images only increased the general enthusiasm for the promised riches of the American West.

An ambrotype is a thin collodion negative on glass that has been laid on a black surface to reflect a positive image when viewed by reflected light. The resultant image had little glare, when compared to a daguerreotype. By 1855 the ambrotype process was well known, and it began to eclipse the older daguerreotype before it in turn was overtaken by the rise of paper printing.

Augusto Ferran (1813–1879)

California Gold Hunter, ca. 1850

Oil on canvas
34 ¾ × 22 inches (88.3 × 55.9 cm)
1972.181

Beginning in 1849, the western slopes of the Sierra Nevada Mountains were overrun with thousands of fortune seekers from all parts of the world who hoped to find success in the rich placer deposits to be found there. Historians have estimated that there were less than fifteen thousand non-Indian people in California prior to the discovery of gold at Sutter's Mill; within three chaotic years, that number had increased to more than a quarter of a million. Although not much equipment or knowledge was necessary to get involved in the mining activity, few of the "forty-niners" were prepared for the hardships that awaited them. Poor living conditions, inflated prices, widespread illness, and uncooperative weather were some of the factors that often led to failure. On the other hand, many enterprising individuals achieved financial success by providing much-needed goods and services to the ever-growing population of the gold fields.

Augusto Ferran, a Spanish artist who had studied in Madrid and Paris, came to California from Havana, where he had taught at the school of art. With another artist, José Baturone, Ferran produced a series of humorous caricatures that depicted the follies and foibles of the ordinary forty-niner. At the same time, Ferran made larger works in oil that ranged from general views to "portraits" such as this one that illustrate the forty-niner as a type. Although this individual appears appropriately dressed and equipped, he looks more like a soldier than a prospector. Like the characters in Ferran's satirical prints, he exhibits the characteristics of a "wild man" in his appearance: swarthy and wary of eye with long, dark hair and a thick, unkempt beard that covers his shirt collar. The writer Bret Harte—whose famed short story "The Luck of Roaring Camp" was published fifteen years after the California gold rush had begun to ebb—described the men who inhabited the camps in a realistic, yet sympathetic manner. "Physically they exhibited no indication of their past lives and character," he observed. "The term 'roughs' applied to them was a distinction rather than a definition."

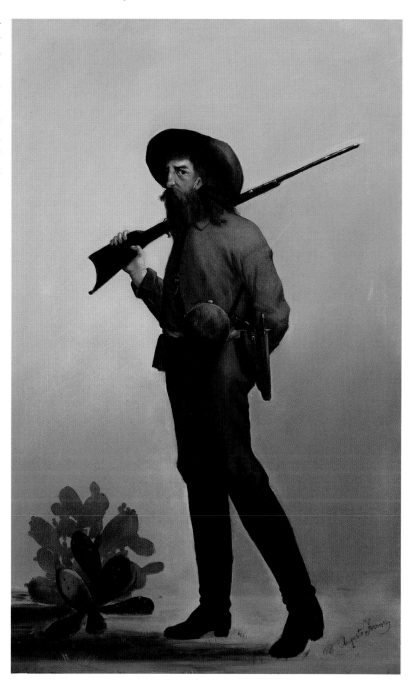

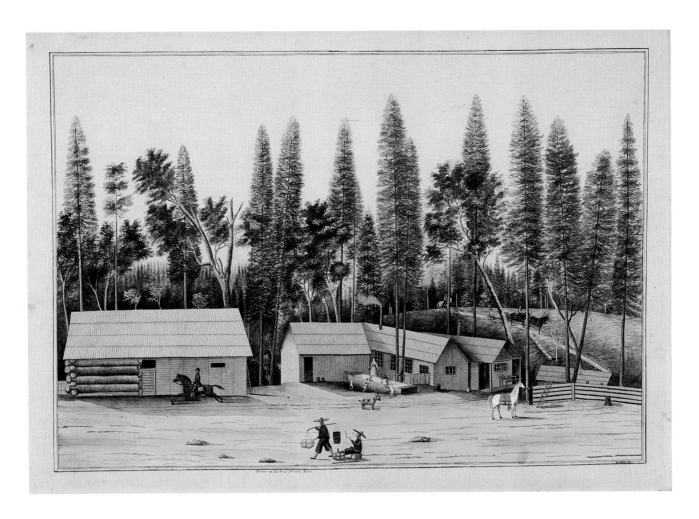

View of Bakers Ranch, Cal.

Henry Miller (active 1856–1857)

View of Bakers Ranch, California, ca. 1856–57
Watercolor and gouache on paper
18 × 25 ⅜ inches (45.7 × 64.5 cm)
1972.98

The buildings in Miller's somewhat naïve view of Bakers Ranch are strikingly similar to those in William Rulofson's contemporaneous photograph on the following page. Miller seems to have been an itinerant artist who traveled throughout California making sketches of everything from small settlements to mission ruins in an effort to make a living. According to some sources, he had a grandiose dream to enlarge some of his views to create a "complete panorama of California" to be exhibited in the United States and abroad, and also hoped to publish an album with "probably two hundred engravings of scenery in California, with short explanatory notes." But Miller's artistic aspirations were never realized, and he appears to have slipped into obscurity.

An old label on the back of this watercolor identifies the subject as a ranch built in 1852 near Volcano Canyon and Michigan Bluff in Placer County. This would place the ranch south of the California Trail, just west of Lake Tahoe. The building at the left may be a barn and stable, for the horseman shown at full gallop in front of it carries saddlebags that are labeled "Wells Fargo Express"; perhaps Bakers Ranch was one of the many stage stops in the gold-mining region. A charming detail at the center of the picture shows a woman drawing water from a trough made of a huge hollowed-out log, while a variety of farm animals clamber up its sides to have a drink for themselves. In the foreground, Miller provides the most intriguing detail of all: two Chinese immigrants in native dress carrying bundles and buckets with shoulder poles, one of whom has paused to rest with a smoke from a long clay pipe. Thousands of Chinese had come to the Sierra placer-mining regions, often taking over claims that had been abandoned and squeezing greater profits from them. Eventually, as the placer mines played out, cheap Asiatic labor was seen as a threat and open discrimination against the Chinese quickly followed. Miller's somewhat placid view of them in his watercolor belies the torments they were subjected to by this period. They were harassed when they came into the towns, and local laws were passed that enforced everything from requiring them to cut their pigtails to preventing them from testifying in court against whites.

William H. Rulofson [attributed] (1825–1878)

[Saw Mill Flat, California], ca. 1858
Pannotype
9 × 12 1/16 inches (22.9 × 30.7 cm)
P1987.12

Rulofson was an established daguerreotypist who had traveled throughout the United States to gain additional training in his chosen vocation. In 1848 he left his family to join the gold rush, but in Sonora, southeast of Sacramento, he teamed up with a man named J.C. Cameron to operate a mobile studio, which may well have been the earliest permanently established photography business on the West Coast. In 1857 Rulofson bought out Cameron's interest and built a frame house and gallery, and he became known as an astute businessman and teacher of many aspiring photographers.

Although Rulofson seems to have worked primarily as a portrait photographer, he produced outdoor views. This rather remarkable image of an early ranch and sawmill is filled with microscopic detail. The most notable aspect proves to be the elaborate wooden fence, made of closely spaced pickets, which surrounds several separate areas of the property. The ranch house itself, in the lower right portion of the picture, is built with rough-sawn siding, but it is also adorned with fancy pedi-mented window-surrounds and a handsome scroll-sawn façade, both painted white. The photograph is so detailed that the careful rows of cedar shakes can be clearly discerned on the house. Two men and another man seated on a horse stand before a smaller building to the left, possibly a bunkhouse or a building associated with the small sawmill just behind it. Piles of freshly cut lumber can be seen in the foreground, and the surrounding landscape exhibits the ravages typical of the American landscape in the frontier era: clear-cut hillsides scarred by logging roads and dotted with tree stumps and other remnants of human exploitation.

Rulofson's photograph is a very rare form called a "pannotype," where a photograph was made on a wet collodion glass plate, then the collodion layer was lifted from the glass and transferred to a piece of dark oilcloth. The resultant image was not reversed, as in a daguerreotype or tintype, but like them it remained a unique, one-of-a-kind photograph. Today, the original image is much harder to see than this reproduction.

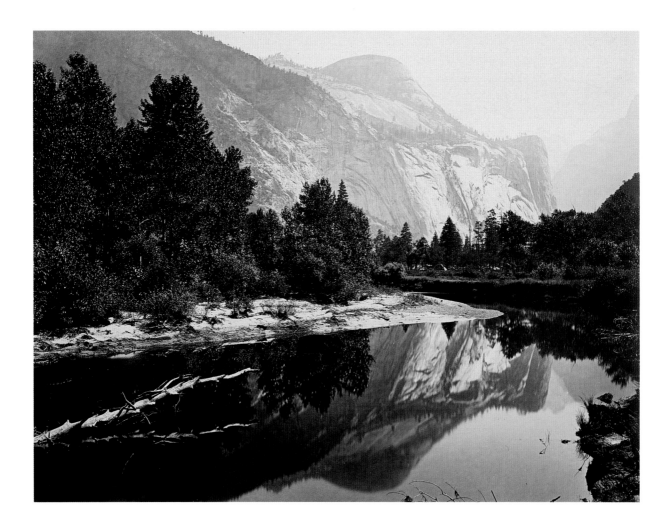

Carleton E. Watkins (1829–1916)

Mirror View from the North Dome, Yosemite, ca. 1865–66
Albumen silver print
15¾ × 20¹¹⁄₁₆ inches (40 × 52.6 cm)
P1989.13.3

Watkins' crystalline views of Yosemite are regarded as the earliest group of photographs to present the western landscape as a wilderness, and the first to present themselves as carefully conceived works of art. Watkins, who was trained in San Francisco, made his first trip to the Yosemite Valley in 1861. At that time the only access to this famed area was through wilderness, since the main trails had not yet been developed. Watkins thus carried all his heavy camera and glass-plate equipment into the area by mule-back. Among the works he produced were huge mammoth-plate photographs of pristine clarity, some as large as 18 × 22 inches. These had to be developed in the field immediately after they were exposed, before the emulsion on the glass plates dried. The finished photographs astonished his contemporaries. Not satisfied with merely presenting his work as mounted prints, Watkins carefully framed and captioned them as fine works of art, exhibiting them in his Yosemite Gallery in San Francisco before displaying them in the East, where they attracted great attention.

This view of Yosemite employs a "mirror view," one of

Watkins' more romantically inspired subjects, and the beautifully balanced composition effectively underscores the majestic grandeur of the scene. The white skeleton of the partially submerged tree in the left foreground, for example, is crucial to counterbalance the dark mass of trees above it and match the lighter reflections of the rock face in the still waters to the right. Another example of the artist's compositional flair is the subtle way he allowed the gentle curves of the outlines of the trees to mimic the crests of the distant rock face. As with many of his photographs, the view here consists of a series of carefully delineated, receding planes that are defined by light and shadow. Also, Watkins developed a special method of printing that enabled him to show objects in the distance—like the rock face in this photograph—as relatively faint. This technique was in keeping with his desire to impart an atmospheric picturesqueness to his scenes, much as a painter might do. Such visual complexity was typical of Watkins' approach—and the principal reason why his work was often imitated but rarely equaled.

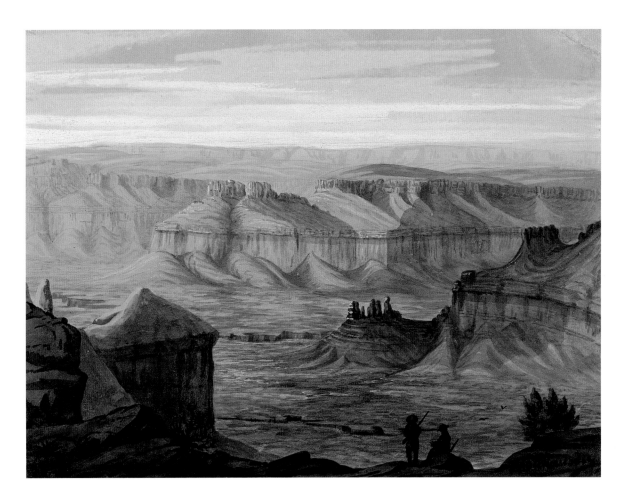

Heinrich Balduin Möllhausen (1825–1905)

Canyon near Cataract Creek, 1858
Watercolor and gouache with gum arabic glazes on paper
8½ × 11¼ inches (21.6 × 28.6 cm)
1988.1.44

During the 1850s, the Colorado River and its canyon lands proved to be a major barrier for overland travelers to California, so the U.S. Army established outposts and began to conduct explorations for better routes through the area. At the same time, growing concern over the growth of powerful Mormon settlements to the north prompted efforts to determine the navigability of the Colorado River itself. In 1857, an expedition headed by Lieutenant Joseph C. Ives set out from Fort Yuma in a specially constructed steamboat named *The Explorer* to journey up the Colorado as far north as possible. Möllhausen, a Prussian artist, writer, and son-in-law of the great German explorer and scientist Alexander von Humboldt, was chosen to accompany the expedition as "artist and collector in natural history." The Ives expedition proceeded up the Colorado as far as Black Canyon, just below the present-day site of Hoover Dam. Then Ives and part of his group, including Möllhausen, struck overland to the northeast, where they encountered the Grand Canyon.

Möllhausen was the first artist to depict the varied landscapes along the Colorado River, but neither he nor his fellow explorers were prepared for the majestic wonders they now beheld. "The view left us speechless," Möllhausen reported, and he worked furiously to record his impressions of the "stupendous chasm" as the expedition made its way along the smaller canyons of the South Rim. His watercolor studies, including this one, are the earliest depictions of the Grand Canyon. This watercolor looks northeast from the head of Driftwood Canyon into Cataract Canyon and shows a section of the Grand Canyon in the distance. "The plateau is cut into shreds by these gigantic chasms, and resembles a vast ruin," Lieutenant Ives wrote in his journal. "Fissures so profound that the eye cannot penetrate their depths are separated by walls whose thickness one can almost span, and slender spires that seem tottering upon their bases shoot up thousands of feet from the vaults below." Möllhausen's watercolor shows two of the expedition's members looking out over the vast landscape that unfolds before them. Contemporary photographs show the artist to have been surprisingly accurate and precise in his rendering, particularly with regard to the geologic features of the area.

John Mix Stanley (1814–1872)

Camp of the Red River Hunters, 1857
Oil on canvas
13¾ × 21⅛ inches (34.9 × 53.8 cm)
1966.52

Stanley was one of the most peripatetic and prolific western artists of his day, though much of his work was tragically lost in a series of fires. Beginning in 1845 he traveled and painted on the southern Plains, through New Mexico to California, and up into the Oregon country before journeying to Hawaii. In 1853, while he was in Washington, D.C., attempting to persuade Congress to purchase a large group of his paintings, he was selected to accompany Isaac I. Stevens on a federally sponsored survey for a northern railway route to the Pacific. Stanley proved to be an able photographer and draughtsman for the expedition; indeed, he is regarded as among the earliest artists to employ the daguerreotype process for documentary purposes.

During the Stevens expedition in 1853–54, Stanley produced hundreds of drawings and sketches, some of which were made into illustrations for the official report and many more that were used as inspiration for later works. This colorful oil sketch, although apparently executed a few years after the event, documents the expedition's encounter on July 13, 1853, with the semi-annual hunt of the Red River settlements, which consisted of an enormous train of 824 carts, 1,200 animals, and 1,300 people.

Stevens noted that the settlers made a series of circular or square "yards" with their carts arranged hub-to-hub for protection. "The tents or lodges were arranged within, at a distance of about twenty feet from the carts, and were of a conical shape, built of poles covered with skins, with an opening at the top for the passage of smoke and ventilation," Stevens further noted. "They were 104 in number, being occupied generally by two families, averaging about ten persons to the lodge. Skins were spread over the tops of the carts, and underneath many of the train found comfortable lodging places." Stanley's sketch generally supports this eyewitness description. The Red River settlements were made up of mixed-bloods, former employees of the fur companies, Indians, and emigrants from virtually every nation in Europe. They dressed in distinctive, colorful ways, spoke a mixed dialect based on French patois, and shared a system of governance derived from Catholicism. Stevens also reported that a small band of Prairie Chippewa (or Ojibwa) Indians accompanied the Red River settlers, and these may be the figures the artist chose to depict in the lower right portion of the painting.

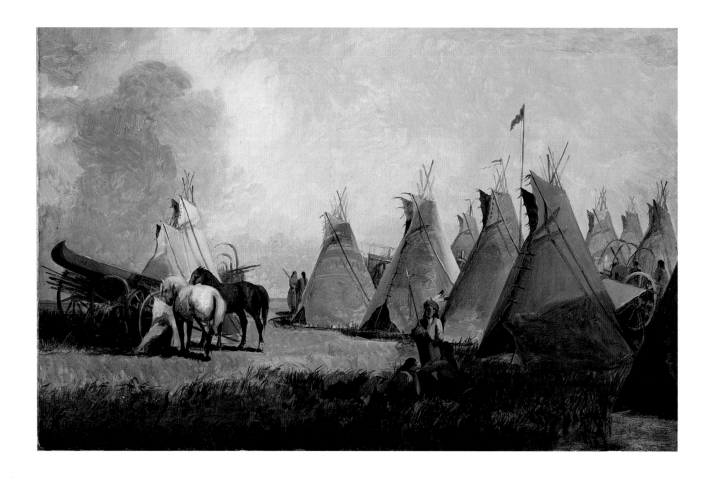

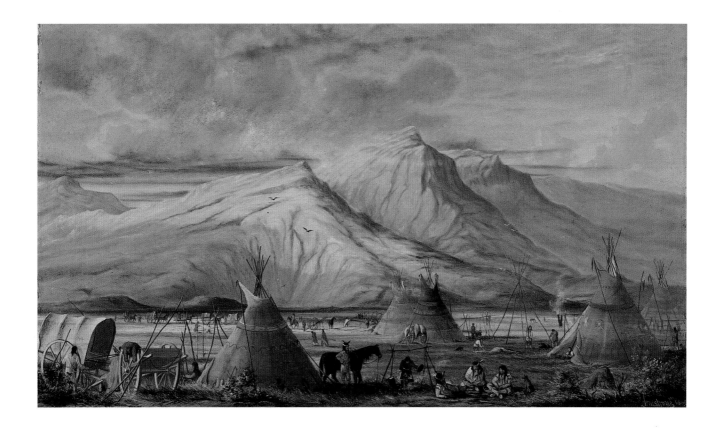

William W. Armstrong (1822–1914)

Métis or Cree Encampment, 1868
Pastel and gouache on paper
17⅝ × 30¼ inches (44.8 × 76.8 cm)
1966.53

For many native tribes and settlers, there were no boundaries between the American and Canadian frontiers, and William Armstrong was one of the earliest artists to depict scenes on the isolated prairies and in the wilderness mountain areas of western Canada. By training and experience he was both an artist and a railway engineer; he successfully exhibited his paintings, taught drawing for many years, and made photographs. His favorite subject was Indians, and from his base in Toronto he ranged widely in search of material for his art. As a road engineer for the Canadian transcontinental railroad, he had ample opportunity to journey through what is today the wide-open and breathtaking provinces of Manitoba, Saskatchewan, and Alberta at a time when those regions were not yet attached to the Dominion, and he avidly sketched the things he encountered. He often worked in watercolor and pastel, and this pastel of a Métis or Cree encampment near some high, though somewhat barren mountains was probably executed during one of his trips.

By the mid-nineteenth century the Cree were one of several Algonquian tribes in Canada who had partially intermingled with the Métis culture, as evidenced by the two-wheeled carts visible throughout Armstrong's depiction. Until they were confined to reserves, many bands of Cree remained nomadic, subsisting on the buffalo and other game that inhabited the open plains. Here the camp seems to be just getting established, since some of the tipis are in the process of being erected. Several animal skins can be seen draped over some of the wagons, indicating that this could also be one of the organized Métis hunts that John Mix Stanley had portrayed in the Dakota Territory a decade earlier. At the time Armstrong executed this view, the future of the lands west of the Red River was being hotly contested by a Métis uprising led by Louis Riel. Fearful of Canadian government authority, the Métis enlisted the aid of English settlers and established a provisional government in Manitoba. William Armstrong witnessed and sketched some of these events as the rebellion was eventually brought to a close. Some of the Métis and their allies moved westward to Saskatchewan in order to preserve their seminomadic way of life, but the arrival of the railroads and agricultural settlement ten years later signaled the end of their independence.

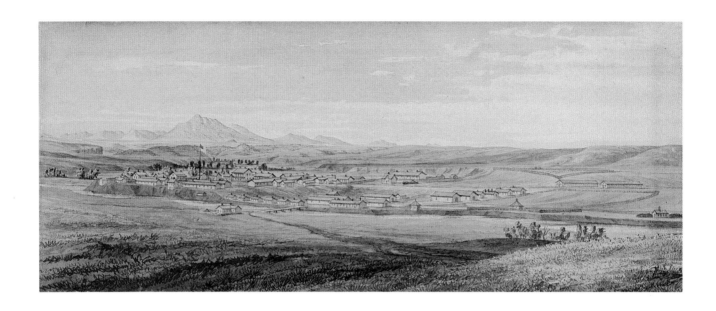

Anton Schonborn (1829–1871)

Fort Laramie, Wyoming Territory, View from the East, 1870
Watercolor and graphite underdrawing on paper
5¼ × 12¾ inches (13.3 × 32.4 cm)
1965.58

By the time this depiction was made, Fort Laramie had already served as a crucial frontier outpost for more than thirty-five years. Established in 1834 at the junction of the Laramie and North Platte Rivers in what is today southeastern Wyoming, Fort Laramie was first part of the flourishing fur trade, before becoming an oasis for thousands of travelers on the Oregon Trail. In 1849 the fort was purchased by the United States government for use as a military post, and it continued to protect gold seekers and emigrants through the 1850s. In 1851 it was the site of a treaty that sought to divide the Great Plains into tracts assigned to certain Indian tribes, but like other treaties of the period it was unrealistic and immediately ineffectual. In 1854–55 there was open conflict with the Northern Cheyenne and Lakota in the area, and the discovery of gold in Colorado at the end of the decade brought an influx of miners and settlers that strained Indian-white relations to their limits. Thus, when Schonborn made this carefully rendered view of the famous fort, it was about to become the center of further conflict with Indian tribes in the area.

Schonborn had received artistic training in his native Germany before immigrating to the United States in 1849. He worked for a time in Washington, D.C., then in 1859 he became the official artist of an expedition under Captain William F. Raynolds that explored the headwaters of the Yellowstone and Missouri Rivers. He was then employed as a draughtsman for the Chief Engineer's office at U.S. Army headquarters in Omaha, and in 1870 was commissioned by Brevet Brigadier General Alexander J. Perry of the U.S. Quartermaster Corps to create depictions of a number of forts in Colorado, Utah, and Wyoming Territories, as well as Nebraska. His view of Fort Laramie is a meticulous rendering of the buildings and topography of the surrounding landscape. Here the buildings and compound of the old fur-trading post have been replaced with barracks, officers' quarters, and parade grounds; a newly built bridge crosses the river where horses and men once had to ford. In June 1871, shortly after he completed these views, Schonborn became the chief topographer on a historic exploration under Ferdinand V. Hayden of what was to become Yellowstone Park. He produced a number of maps and charts for the expedition and was promised further employment in Washington, but for unknown reasons he committed suicide shortly after his return to Omaha. A train ticket to Washington was found in his pocket.

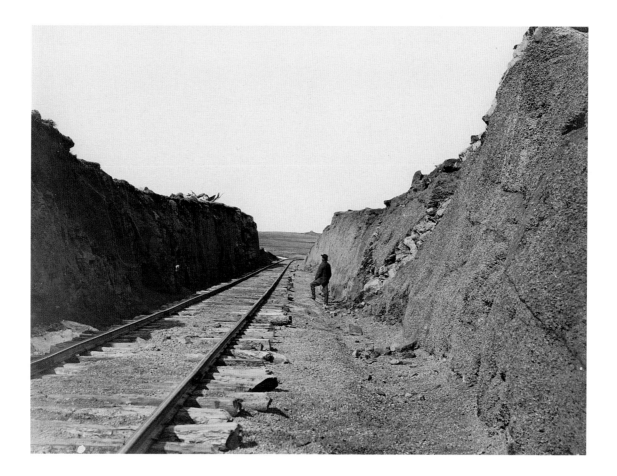

Andrew J. Russell (1830–1902)

Malloy's Cut, ca. 1868
Albumen silver print
9¼ × 12⅛ inches (23.5 × 30.8 cm)
P1983.44.4

Although Russell has the distinction of being the first member of the U.S. Army officially assigned to photograph the Civil War, he is more famous for the stunning landscape photographs he produced in the Far West. He was a member of Clarence King's surveying party beginning in 1867 in the rugged mountains of Utah, and like many photographers of his day he had to overcome major obstacles in order to create successful images. He found, for example, that most of the available water was too alkaline to use for developing negatives; instead, he had to carry good water as far as fifty miles to achieve his desired ends. On at least two occasions his horses bolted on the steep hills, carrying away his valuable equipment, and there was always the danger that the large, heavy glass negatives that he used would be broken in transit over the rough terrain. At one point Russell invented a 17 × 21-inch camera, which he claimed was lighter than a commonly used model, for 10 × 12-inch plates. Such inventiveness—to say nothing of outright perseverance—was required in order to photograph the harsh lands of the unsettled West.

Russell is justly famous for photographs taken while documenting the construction of the Union Pacific Railroad across the Great Plains, including those he took at the joining of the transcontinental railroad at Promontory Point, Utah, in May 1869. That same year, the railroad published an album of fifty of Russell's albumen prints titled *The Great West Illustrated in a Series of Photographic Views Across the Continent*; it included the depiction of "Molloy's Cut" seen here. The site, near present-day Sherman, Wyoming, lay in desolate, open country, which Russell emphasizes in the dramatic composition of this photograph. The single figure, standing by the freshly laid track that sweeps through the cut into the distance, seems overwhelmed by the immensity of the space and the loneliness of the landscape itself. Russell, who was originally trained as a painter, often adopted the compositional conventions typical of the landscape painters of his day to heighten his visual message. At the same time, the pristine clarity and starkness of his images were a strong rebuttal to those who claimed the western landscape to be one of romantic beauty and fertile abundance.

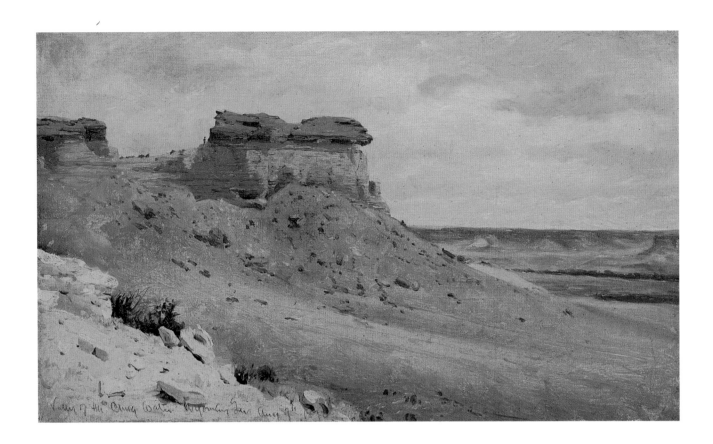

Sanford R. Gifford (1823–1880)

Valley of the Chugwater, Wyoming Territory, 1870

Oil on canvas

7¾ × 12⅞ inches (19.7 × 32.7 cm)

1970.67

In July 1870 Gifford made his first trip to the American West, traveling to Denver on the newly completed transcontinental railroad in the company of two friends and fellow painters, John F. Kensett and Worthington Whittredge. In his later autobiography, Whittredge recalled that Gifford was ready to paint the glories of the Rocky Mountains, but he met and quickly "fell under the spell" of Ferdinand V. Hayden, the energetic and irrepressible scientist and head of the United States Geological Survey, who persuaded Gifford to accompany an expedition he had organized to explore certain areas of the Wyoming Territory. The two men traveled north and joined the expedition at Cheyenne, where the painter struck up a fortuitous friendship with William Henry Jackson, a photographer whom Hayden had also asked to accompany the expedition as his guest. Over the next several weeks Gifford produced a number of field sketches, including this one, before leaving Hayden's group at Fort Bridger.

In his official report of the expedition Hayden noted that Jackson, "with the assistance of the fine artistic taste of Mr. Gifford, secured some of the most beautiful photographic views

which will prove of great value to the artist as well as the geologist." In fact, in a rare instance of documentary evidence of an expeditionary artist at work, one of Jackson's photographs—now in the collection of the Amon Carter Museum—shows Gifford seated with his paint box and sketching board on the morning of August 9, creating the very same view of the flat-top bluffs above the Chugwater River that is reproduced here. Today, Interstate 25 cuts between the bluffs and the river below, but in 1870 the region was not easily traversed, much less understood. Prior to his trip west, Gifford had traveled widely in Europe and the eastern United States, seeking to paint what was beautiful, or what his friend Whittredge termed "the living, the perfect, the strong." His simple sketch of the formations above the Chugwater Valley show an artist who managed to find a different kind of beauty in the stark western landscape. His influence on the younger Jackson—who was about to go on to participate in Hayden's momentous survey of the Yellowstone country—seems to have been highly significant for the photographer's later career.

Timothy H. O'Sullivan (1840–1882)

Water Rhyolites, near Logan Springs, Nevada, 1871
Albumen silver print
8 × 10⅞ inches (20.3 × 27.6 cm)
P1982.27.13

As the Hayden expedition was getting ready to explore the Yellowstone country, a more ambitious expedition under the command of Lieutenant George M. Wheeler was underway in the territories to the south. While Hayden worked for the Department of the Interior, Wheeler was assigned by the army to head a competing program known as the United States Geographical Surveys West of the One-Hundredth Meridian. In 1871 Wheeler assembled an expedition at Fort Halleck, Nevada, that included Timothy O'Sullivan, a skilled photographer who already had done significant work in the West for Clarence King's survey of the Fortieth Parallel. The expedition moved south through Owens Valley, crossing Death Valley in July, where there was much hardship and the temperatures got so hot that O'Sullivan's photographic chemicals supposedly boiled. Reaching the lower Colorado, part of the expedition, including O'Sullivan, ascended the river through the Grand Canyon to the mouth of Diamond Creek before returning northward west of the Virgin River. It was there that O'Sullivan made this photograph of the relatively new mining settlement of Logan Springs near Irish Mountain, not far from the present-day town of Hiko, Nevada.

O'Sullivan was interested in recording the geologic features of the country through which the expedition passed, and here he noted the rhyolite-layered formations in the vicinity of Irish Mountain. Equally interesting, however, are the stone buildings that appear in O'Sullivan's view. Lumber for building had to be brought to this part of Nevada from as much as 150 miles away, and it was correspondingly very expensive. The stone buildings seem to blend in with their stark surroundings, and indeed O'Sullivan was one photographer who was apt to frame his subjects so that man was shown somewhat in harmony with nature, not in opposition to it. Logan Springs—also called Logan City—had been founded only five years before Wheeler and O'Sullivan saw it, when rich-looking silver ore had been discovered in the area. Like many mining towns that grew suddenly with the promise of prosperity, Logan Springs lived a brief life before its source of wealth ran out. Today it is one of many ghost towns in the region.

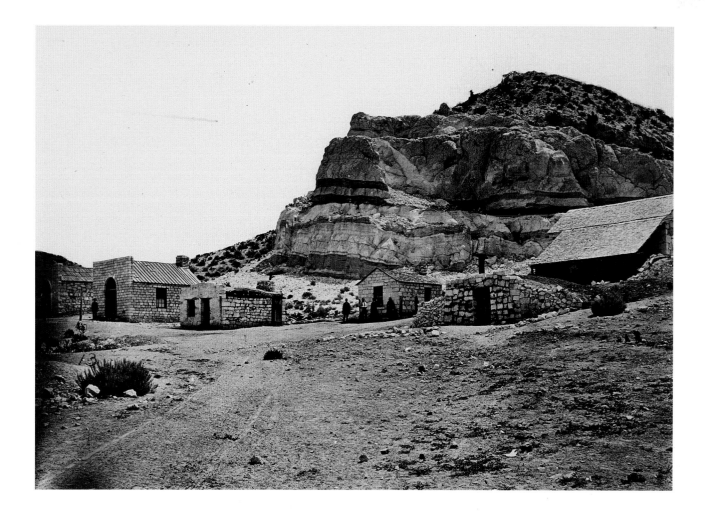

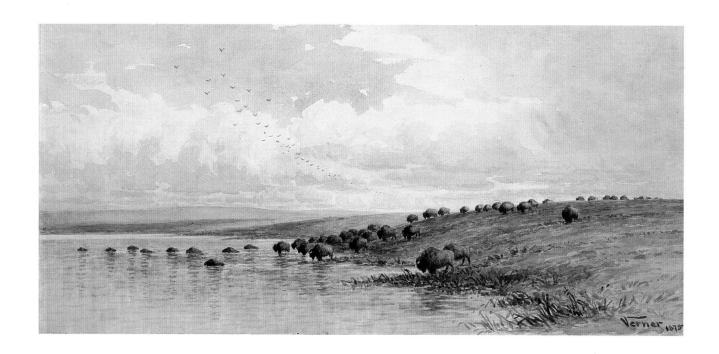

Frederick A. Verner (1836–1928)

Herd of Buffalo Crossing the Upper Assiniboine River, 1875
Watercolor, gouache, and graphite underdrawing on paper
12⅛ × 25½ inches (30.8 × 64.8 cm)
1964.5

In 1873 Verner—a Toronto-based artist who had trained in England—made his first trip west into the new province of Manitoba. Great changes were underway in that part of the country. The Hudson's Bay Company had ceded the whole vast area of the Northwest Territories to Canada, and negotiations were then underway with the native tribes who inhabited the area. Verner, who was keenly interested in painting the Indians, hastened to the site of the treaty talks at Lake of the Woods. He traveled and sketched throughout the area, visiting Fort Francis and following the Winnipeg River southward. The many sketches he produced of the native peoples and wide-open spaces he encountered became a basis for much of his later art. Although many portions of the countryside through which he passed were anything but inviting—having been described by his contemporaries as alternately rocky, swampy, sparsely forested, or simply burnt over—Verner preferred to depict them as somewhat beautiful and picturesque. In the same way, he chose to portray his Native American subjects in an idealized manner, without regard to the fundamental changes that were then sweeping through their cultures.

Verner's idealized approach was typical of many artists of his day, all of whom preferred to romanticize their western subjects to fit the demands of the popular imagination about the "Wild West." For this reason he became very interested in painting the bison, even though the nearest animals were more than 300 miles west of where he visited. The subject of this watercolor, though skillfully handled and beautifully evocative of the open frontier, is a fabrication of the artist's own mind. The landscape itself may be quite accurate, for Verner had traveled to Fort Garry, where the Assiniboine River connects with the Red River; but the only bison the artist could have seen in this period—for he would not go further west in his travels until 1890—were those to be found in captivity. Indeed, at the time of Verner's formative trip west the animals were no longer in Manitoba. The magnificent bison, once numbering in the millions across the North American continent, were then being savagely hunted to extinction. In 1879, just four years after Verner completed this watercolor, the animals officially disappeared from all of Canada.

George Caleb Bingham (1811–1879)

View of Pike's Peak, 1872

Oil on canvas
28 × 42⅛ inches (71.1 × 107 cm)
1967.27

In August 1872, Bingham traveled to the vicinity of Colorado Springs (then called Fountain Colony) and Manitou Springs to seek respite from recurring troubles with consumption. He had already enjoyed a successful career as a painter of Missouri and Mississippi River genre scenes, and his trip to Colorado was the first time he had visited the Far West. The area south of Denver along the eastern front of the Rockies was being publicized by the Denver and Rio Grande Railway as a scenic wonderland, and a large number of mineral springs and comparatively dry air underscored the region's appeal for those who suffered from a variety of health problems. Indeed, by the turn of the century the railroads would establish Colorado Springs and Manitou Springs—dubbed the "Saratoga of the West"—as major resort centers. But at the time Bingham visited them, that process was only just beginning.

During Bingham's two-and-one-half-month stay in the area, he sketched and painted in several locations. He was particularly attracted to the grandiose beauty of Pike's Peak, and the view in this painting is taken from a point at the confluence of Monument and Fountain Creeks, near a sight on the high Plains known as "Jimmy's Camp," a common stopping point for wagons. Monument Creek can be seen in the opening through the trees at the lower right in the painting. Interestingly, Bingham exaggerated the height of the peak as seen from this vantage point today. He purposely sought a more dramatic effect in the view, possibly due to the popularity at the time of the histrionic canvases of contemporary artists like Albert Bierstadt and Frederic Church. However, a local reporter didn't seem to mind Bingham's departure from scientific accuracy, for he praised the artist's depiction of the "towering height of that grand mountain," declaring that viewers would feel "as they stand before this work of art that they are in the presence of the reality of towering crags and snow-capped peak." The reporter lamented the news that the artist's painting was being shipped east to be sold. "Mr. Bingham's pictures are known throughout the land," he noted, "and there should be some pride felt in retaining this one near the scene of which it is the counterpart."

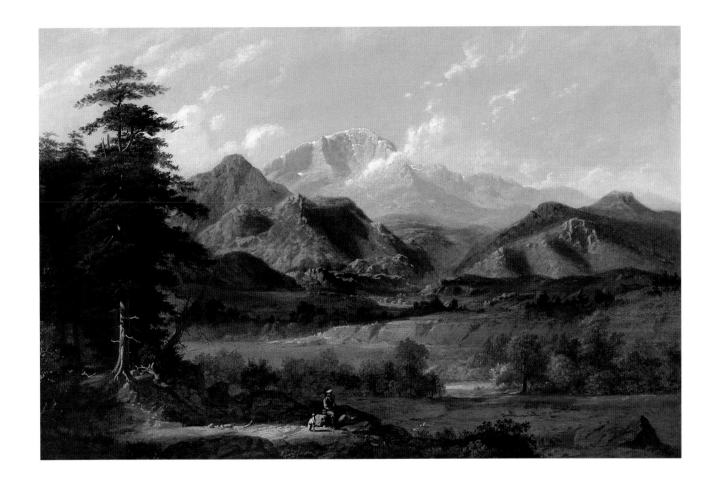

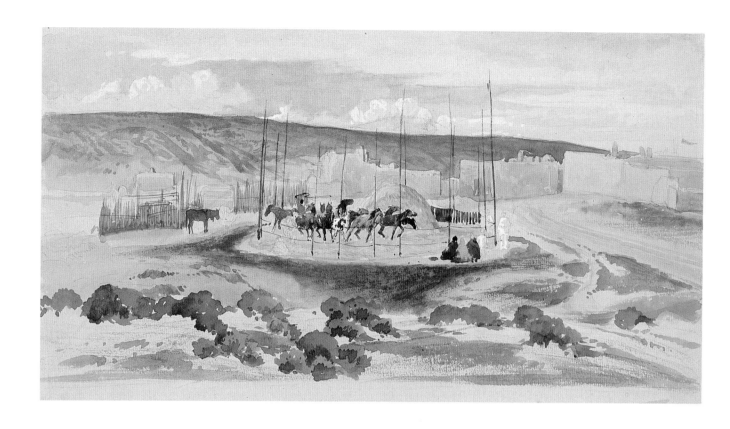

Peter Moran (1841–1914)

Threshing Wheat, San Juan, ca. 1880–83
Watercolor, gouache, and graphite on paper
7⅜ × 13⅜ inches (18.7 × 34 cm)
1965.78

As a painter of the American West, Peter Moran was not as prolific as his older brother Thomas, but he nevertheless created a number of significant depictions. In the summer of 1880 he made his first of four trips to the Southwest, and that August visited San Juan Pueblo on the Upper Rio Grande, about thirty miles north of Santa Fe, where he witnessed the natives threshing grain in an age-old way. Ernest Ingersoll, a traveler who visited the pueblo a few years later, described the circular spaces of high ground that had been surrounded by evenly spaced, tall poles. "When the threshing is to be done, a rawhide rope or two is stretched about these poles to form a fence, and often upon this are hung many blankets, the gay colors and striped ornamentation of which make an exceedingly picturesque scene," he wrote. Such blankets can be seen on the far side of the circular fence in Moran's watercolor.

Once the fence was complete, Ingersoll described how the sheaves of grain belonging to four or five families were piled in the center of the enclosure. Then a small flock of sheep, goats, or horses was driven into the space and around the circle, gradually spreading and beating the grain under their hooves. "Behind them race two or three athletic, bare-headed and scantily-dressed youths, cracking long whips, hustling the laggards, and nimbly keeping out of the way of the kicking, crowding and bewildered animals," wrote Ingersoll. "This is quite as hard work as any of the horses or goats do, and is accompanied by continual halloos and trilling cries, which almost make a song when heard at a little distance." In Moran's vibrant watercolor, a figure with a whip can be seen amidst the horses to the left. A number of other figures are outlined only in graphite around the edges of the enclosure; Moran seems to have been primarily concerned with visual and coloristic effects of the horses and enclosure itself, as well as the surrounding landscape. Although this rich watercolor is not dated, it probably derives from Moran's initial studies made in August 1880. Moran's work eventually landed him a position as one of the five artists for the massive U.S. Government Census investigation of 1890, which resulted in the 683-page illustrated *Report of Indians Taxed and Indians Not Taxed,* the largest such report ever undertaken.

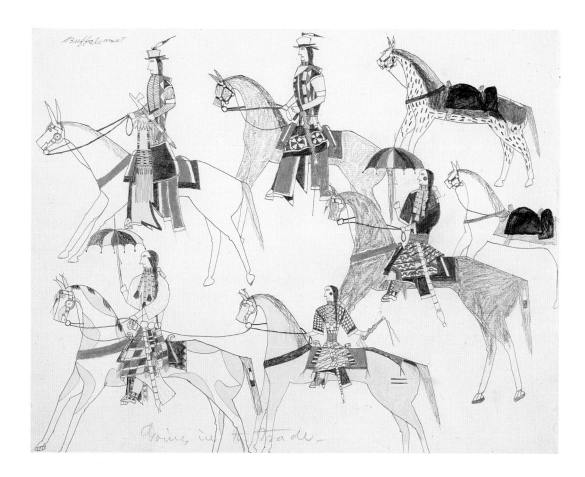

Buffalo Meat [Oewotoh] (1847–1917)

Going in to Trade, 1876
Pen and ink, colored pencil, and graphite on paper
8¾ × 11¼ inches (22.2 × 28.6 cm)
1965.48.7

The magnitude of the change brought to Native American life by the arrival of the white man can scarcely be imagined. On the southern Plains, a succession of treaties eroded their traditional lands, and settlers, miners, and hunters constantly pushed into the remaining areas that were assigned to them. There the allied tribes—Kiowa, Comanche, Cheyenne, and Arapaho—continued to leave their reservations to search for buffalo, steal horses, or make raids on their enemies. By 1874, the general outcry from the white settlers forced the U.S. Army to act. The renegade bands were relentlessly pursued, their camps successively burned as they paused to rest. The Indians thus had scant food and shelter for the coming winter, which proved to be unusually severe, and many of them died. Little by little, remnants of the isolated bands came to the agencies to surrender, and the leaders of the groups were taken into custody to be imprisoned.

More than seventy Indians described as principal troublemakers were sent in chains by rail to Fort Marion, Florida. One of these was Buffalo Meat, a "ringleader" whose Cheyenne name was Oewotoh. Many of the prisoners were subsequently taught to read and write, and they were encouraged to pursue other activities. Buffalo Meat chose to draw. Done with colored pencils on simple ledger book paper, this type of drawing was a westernized version of the pictographic hide paintings that chronicled the exploits of a Plains warrior earlier in the century. Here, a group of five brightly adorned figures on horseback are shown leading two packhorses, presumably loaded with hides, to trade. The figures are dressed in all their finery, and two of them hold brightly colored umbrellas to ward off the sun's rays. Such drawings display the conventions typical to Plains Indian expression, such as hierarchical perspective and importance determined by size or amount of detail. Color and line were not used to indicate depth, and there is no background. Not surprisingly, many of these drawings were nostalgic for the old ways, before the time of their troubles with the white man. Upon his release from prison, Buffalo Meat returned to his reservation in 1878, where he served as a head chief of the tribe, a policeman, a commissary worker, a teamster, a deacon in the Baptist Church, a mission representative back East, and a delegate to Washington, D.C.

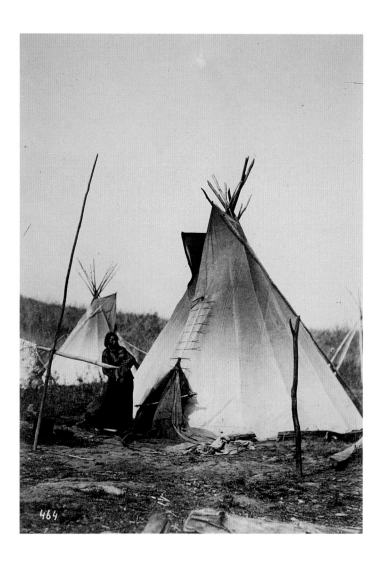

William Henry Jackson (1843–1942)

Gihiga's Lodge, Omaha, 1868–69
Albumen silver print
7⅜ × 5¼ inches (18.7 × 13.3 cm)
P1970.54.11

In his fascinating autobiography titled *Time Exposure*, Jackson recalled establishing his own photography business with his brother in the fledgling town of Omaha in 1867, more than seventy years earlier. "For the first year we stuck pretty closely to the work of studio photographers," Jackson noted. "The business paid well enough, but it was hardly exciting." However, he soon began photographing the bands of Indian tribes living in the area: the Osages and Otoes to the south, the Pawnees along the Platte River to the west, and the Winnebagoes and Omahas to the north along the Missouri River. "Those Indians would pose for me by the hour for small gifts of cash, or just for tobacco or a knife or an old waistcoat," Jackson remembered. "And I in turn was able to sell the pictures through local outlets and by way of dealers in the East. To handle this work I devised a traveling darkroom, a frame box on a buggy chassis, completely fitted out with water tank, sink, developing pan, and other gear essential to a wet-plate photographer."

Many of Jackson's photographs of these tribes were later added to the body of work that constituted The United States Geological Survey of the Territories, for in 1871 Jackson left his Omaha studio to accompany Dr. Ferdinand V. Hayden on his monumental exploration of the Yellowstone region. This photograph depicts what is presumed to be the wife and child of Gihiga, one of the nine principal chiefs of the Omaha, in front of their tipi. An animal hide can be seen drying on a rack to the left, but the tipi itself is not made of hide, as in the old days, but canvas. In his comments on the history of the tribe, Jackson noted that at the beginning of the century their numbers had been drastically reduced by smallpox, and they were gradually pushed to their present location by their relentless enemy, the Lakota. By the time Jackson visited them the tribe numbered around one thousand and depended "entirely upon their crops for their subsistence, of which they have considerably more than enough for their own use." He seemed to imply that scenes such as his view of Gihiga's family and tipi were rapidly disappearing. "The older Indians are also abandoning their old habits," he noted, "and assisting in building for themselves upon forty-acre allotments of their lands."

William Fuller (1842–1922)

Crow Creek Agency, D.T., 1884
Oil on canvas
24⅝ × 51¾ inches (62.6 × 131.5 cm)
Acquisition in Memory of Rene d'Harnoncourt,
Trustee, Amon Carter Museum, 1961–1968
1969.34

In 1863 a reservation was established at Fort Thompson, along the Missouri River in the Dakota Territory (now part of South Dakota). The reservation took its name from Crow Creek, which emptied into the larger river about five miles downstream. Within a few years elements of several tribes—including the Yanktonnais, Yanktons, and Tetons—were living on the reservation. As historians have noted, the agency had the daunting task of teaching agricultural methods to the Indians, utilizing land that was wholly unsuited for it. Some time after 1871, Irish-born William Fuller arrived at the agency from Chicago to work as a carpenter and teacher. According to family tradition, Fuller had studied drawing in England before coming to America. At the agency he apparently took a few weeks off in the early summers to paint, and this extraordinarily detailed painting of the agency is one of the fruits of his labors.

The Episcopal Church and rectory can be seen just behind the central tipi, and the fenced area to the right contains the government school and the boys' and girls' dormitories. Smoke rises from the mill building in the central background, while other structures such as a hospital, residences, officers' quarters,

barns, blacksmith and carpenter shops, and a granary may be seen as well. There are several areas under cultivation, and numerous tipis are scattered across the fields surrounding the agency buildings. In the foreground, Fuller portrayed several prominent individuals then living and working at the agency. The figure labeled as number one is White Ghost, chief of the Yankton tribe, who chose not to adopt the white man's mode of dress or religion. Next to him is Drifting Goose, Chief of the Hunkpati band of Yanktonai Sioux, and to his right is Wizi, a cousin of White Ghost who accepted the white man's ways and managed to keep disputes on the reservation to a minimum. The bearded man standing next to the wagon is Mark Wells, an interpreter, while the man on horseback is his brother Wallace, a farming supervisor. In similar fashion, Fuller labeled and recorded every personage and feature in his carefully crafted painting so that future generations would know more about the place where he worked. The painting's placid quality, however, belies the very real problems such social changes entailed for a people who had mostly wandered and hunted for their livelihood.

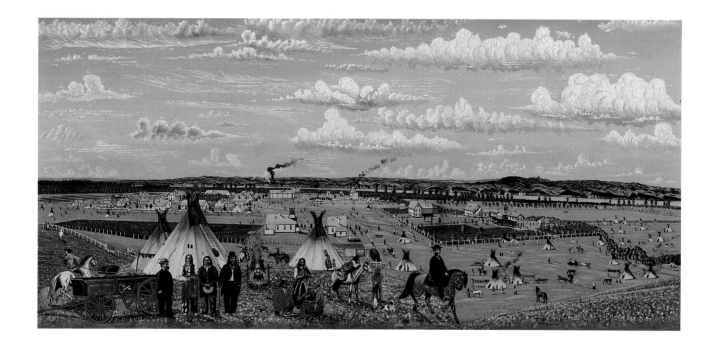

Charles D. Kirkland (1857–1926)

Throwing a Steer, ca. 1877–87

Albumen silver print

4⅜ × 7⅜ inches (11.1 × 18.7 cm)

P1979.36.14

Following the completion of the transcontinental railroad, the territories of Montana and Wyoming experienced the rapid rise of the open-range cattle industry. Southeastern Wyoming, where the growing frontier town of Cheyenne straddled the tracks, became a primary destination for cattle herds driven north from Texas. Shortly after Sanford Gifford painted the valley of the Chugwater River while on the Hayden Survey, the area filled with Longhorn herds thriving on the rich grasses to be found there. By 1875, the open-range system was well established in southern Wyoming. A year later, following the defeat of General George A. Custer and the subsequent subjugation of the Lakota and Cheyenne Indians, the vast grazing areas north of the Platte River and east of the Bozeman Trail were opened to the ranchers as well.

In 1877 Charles Kirkland moved to Cheyenne from Denver, where he had operated a photographic studio. He immediately began photographing cowboys and ranch life, creating numerous images that he advertised as "graphically and truthfully the cattle business of the Great West." One series of eighty photographs consisted of "Views of Cow-Boy Life" that were "finely finished and elegantly mounted on five-inch by eight-inch cards." They cost thirty-five cents apiece, or four dollars a dozen. Kirkland's photographs were taken under demanding conditions and are important early records of the cowboy at work on the open range. This particular example shows a group of riders having roped a recalcitrant steer. Most of the men in the photograph may be seen wearing some of the clothes that became the "uniform" of the cowboy on the northern Plains. The vest was adopted for warmth and the handy storage of matches, tobacco fixings, pencils, and tally books, and the short-brimmed hat replaced the broader-brimmed hats of the South in order to combat the strong northern winds. The rider in the foreground on the right has a lightweight Texas-style saddle with double cinches (called "double-rigging") for greater stability, short outer skirts behind the cantle, and a strong saddle horn around which he has wrapped his lariat to bring it taught. His boots rest in broader box-style stirrups, and he wears simple drop-shank spurs. In the early days of the open range, it was usually easy to tell where a cowhand came from by the style of his outfit, whether the South from Texas and Mexico or the West from Oregon and California.

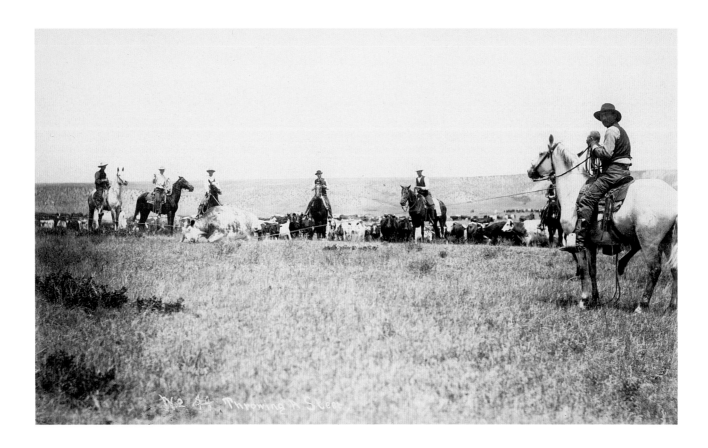

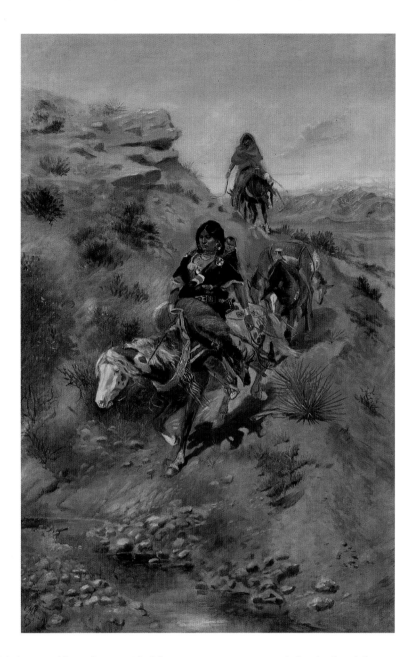

Charles M. Russell (1864–1926)

Bringing Home the Meat, ca. 1891
Oil on canvas
36⅛ × 24⅛ inches (91.8 × 61.3 cm)
1961.194

At the time the open-range cattle industry was establishing itself in Wyoming, similar developments were happening in Montana Territory as well. Russell arrived there in 1880 as a green sixteen-year-old with a lifelong desire to be a cowboy, and after a few fits and starts he got his wish. He became a night wrangler—one who herds the cattle outfit's string of horses while everyone sleeps—and participated in the fall and spring roundups in the rich grasslands of the Judith Basin in central Montana. Although Russell had little formal training as an artist, he developed his abilities through careful observation and continual practice, and he began to create memorable and accurate images of cowboy and range life. By the end of the 1880s, Russell began to develop a national reputation as Montana's "cowboy artist."

The cattle country of the Judith Basin had been surrendered by the Blackfeet soon after Russell arrived in Montana, and from the beginning he showed an active interest in depicting them. He visited several reservations as early as 1888, and he endeavored to learn as much as he could about their culture, including their legends, beliefs, and customs. This painting shows a Blackfoot woman returning with her husband from a successful hunt. She carries the carcass of a pronghorn antelope across her saddle, while leading a packhorse over which two additional antelope are tied. Her husband follows in the rear, wrapped in a hooded blanket, with a fourth carcass slung over his saddle. Russell's early paintings of Indians are noted for their accuracy of detail, and this work is no exception. The woman's paint horse exhibits the short nose and small stature typical of its breed, and the beaded and fringed martingale across the front of the horse is an example of a type of which few have survived. The woman wears a dress made of strouding cloth, an English trade cloth that was either bright red or indigo, as seen here. The material had a white selvage that the Indians preferred to retain as decoration, and here the seams have been enlivened with red ribbon, which was a common practice at the time. Russell left a valuable record in his sympathetic paintings of the Blackfeet and other tribes, for their way of life—even the freedom to hunt wild animals, as shown here—was undergoing fundamental and irreversible change.

Harry Learned (1842–after 1895)

Robinson, Colorado, 1887

Oil on canvas
18 ¼ × 30 ½ inches (46.4 × 77.5 cm)
1963.10

In the late 1870s, a number of rich deposits of lead-silver ore were discovered in the vicinity of Ten Mile Creek, a district north of Leadville on the western slope of Colorado's Rocky Mountains. One of the mining towns that grew to prominence in this area was Robinson, named for George B. Robinson, a prominent Leadville businessman and mining investor. Prospectors working for Robinson had discovered several rich claims on nearby Sheep Mountain, and by 1878 a general rush to the Ten Mile District was underway. This painting depicts the town of Robinson in its heyday, about six years after the Denver and Rio Grande Railroad had extended its lines through the valley. Ten Mile Creek can be seen snaking its way alongside the tracks, and the chain of peaks to the east probably includes Fletcher Mountain to the left and Bartlett Mountain to the right. In the left foreground are the buildings and stacks of the large smelter built by George Robinson to process the ore that came from his mine, one of the most productive in the region.

The artist who depicted this deceptively picturesque scene, Harry Learned, was relatively unknown until historian Patricia Trenton discovered the details of his life. Learned first came to Colorado on the eve of the Civil War, at the height of the Pike's Peak gold rush. In 1869 he traveled to Chicago to study art, and a year later he had a studio in Lawrence, Kansas. Within a few years he had relocated to Denver, where he drew notice in the local press for landscape views that were "very true to nature." As with many artists seeking to make a living, Learned did everything from portraits and landscapes to "skill in lettering on glass and signs" to make ends meet. He then led a somewhat peripatetic existence, living in Boulder and Longmont—where he was employed as "scenic artist" for the Fort Collins Opera House. His success at this led him to jobs for the Greeley Opera House and the Denver Palace Theater. By 1884 he was married and living in the vicinity of Robinson, where he painted a number of "souvenir views" like this one that belie the great changes that mining activity was forcing upon the region. Today, all of this is gone. The site of Robinson and other nearby communities lie under the vast tailings of one of the world's most productive open-pit molybdenum mines.

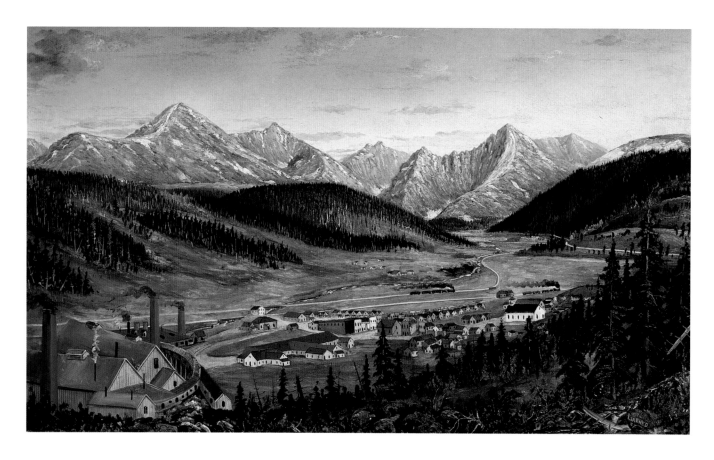

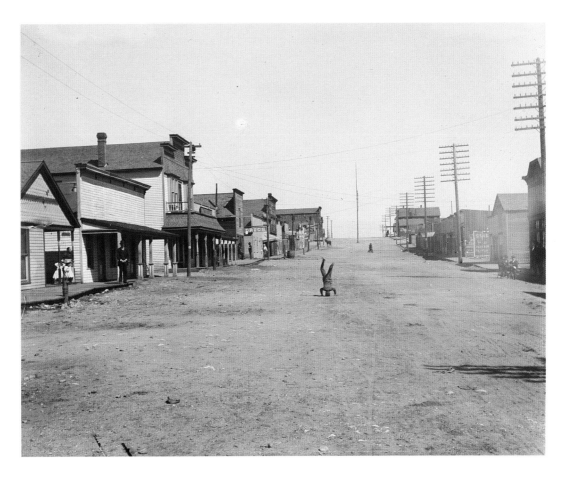

Artist Unknown

Altman [Colorado], ca. 1896
Collodion-chloride print
3¹³⁄₁₆ × 4¾ inches (9.7 × 12.1 cm)
P1976.11.6

At the beginning of the last decade of the nineteenth century, the area around Cripple Creek, southwest of Pike's Peak, became the scene of a wild gold rush. Cripple Creek itself and several other surrounding towns like Victor, Goldfield, Independence, Elkton, and Altman grew almost overnight from small gold camps to thriving towns. Before the mineral deposits petered out and the towns inevitably declined or disappeared, more than $400 million in gold would be removed from the region. Altman, located on Bull Hill about three miles north of Victor, was reportedly a miners' town, known as a hotbed of union sympathy at a time when labor strife was becoming common in the mines. By the 1890s, the Colorado mining frontier had changed to reflect the complexities of the times, and in 1894 Altman made the headlines when miners barricaded themselves in the center of town with a catapult that hurled beer bottles stuffed with dynamite. In Altman, union sentiment was such that a favorite children's game was one called "Miners and Deputies."

According to contemporary accounts, Altman was built in about six weeks. This photograph probably depicts the main street of the town not long after it was established. In its heyday

it was billed as the world's highest incorporated town, at an elevation of 11,146 feet. A writer for *Leslie's Weekly* noted that Altman at its height was "beastly prosperous," because "every man willing to work earns four dollars a day, working only eight hours." On the other hand, the magazine reported the town's prosperity was also reflected in the number of saloon keepers, gamblers, and "soiled doves" to be found there. As the photograph indicates, the little town—whose population peaked at 1,200 in 1899—was hardly distinguished architecturally. Yet the simple false-front buildings, wooden sidewalks, and wide dirt streets echoed the appearance of a hundred other communities like it in the development of the American West. Perhaps the photograph was taken on a Sunday afternoon; the street is virtually empty, except for the boy who playfully stands on his head, adding a wonderfully unexpected, almost absurd element to the scene. The little girls on the sidewalk to the left wear white pinafores, and most of the men appear to be wearing suits and short-brim hats. Unfortunately, Altman's promise of prosperity was short-lived. Its post office ceased operations in 1911, and little of the town remains today.

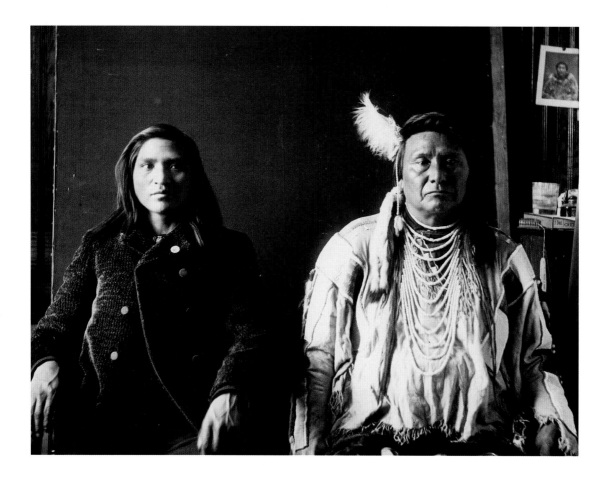

Wells Moses Sawyer (active 1895–1898)

Chief Joseph and Nephew [Hinmaton-Yalakit, also Hin-Ma-Toe-Ya-Lut-Kiht; or,
Thunder Coming from the Water Up Over the Land, and his nephew, Amos F. Wilkinson], 1897
Platinum silver print
7½ × 9½ inches (19.1 × 24.1 cm)
P1967.2696

In 1897, when the great Nez Perce leader Chief Joseph made a journey to Washington to meet with President William McKinley, he was something of a national hero. Twenty years earlier he had achieved near-mythical status in the aftermath of the Nez Perce uprising. Although this was seen as one of the most brilliant and gallant struggles of its time, it largely resulted in death, defeat, and destitution for the Nez Perce people. From exile first on reservation lands in Oklahoma, then on Nespelem Creek near Colville, Washington, Chief Joseph waged a tireless campaign on behalf of his followers. "I do not understand why nothing is done for my people," he told a large assemblage of government figures during an earlier visit to Washington. "Good words do not last long until they amount to something. Words do not pay for my dead people. They do not pay for my country, now overrun by white men. . . . Good words will not give my people good health and stop them from dying. Good words will not give my people a home where they can live in peace and take care of themselves."

In this photograph, Joseph's weary, yet strong and dignified countenance contrasts sharply with that of his young nephew,

clothed in white man's attire. He had come to Washington to complain yet again of white encroachments on his land, this time the land that was his place of exile, not the homeland in the Wallowa Mountains in Oregon to which he wished his people to return. During this trip, he was invited to New York City to ride in a place of honor in the parade of dedication for Grant's tomb. He rode with Buffalo Bill Cody and the two military generals who had conquered his people, but as a mythical symbol of a West that existed only in the imagination—a West that consisted only of "good words." Chief Joseph bore all this with dignity, and never gave up. "I know that my race must change," he told a large group of congressmen in 1879. "We only ask an even chance to live as other men live. We ask to be recognized as men. We ask that the same law shall work alike on all men." Although many Nez Perce were finally allowed to settle in portions of Idaho, Chief Joseph himself continued to work to regain a portion of their ancestral lands in Oregon, but in the end was not successful. "It makes my heart sick when I remember all the good words and all the broken promises," he said. He died in exile on September 21, 1904, in front of his tipi fire.

Frederic Remington (1861–1909)

Lieutenant S.C. Robertson, Chief of the Crow Scouts, 1890

Watercolor, opaque white, and graphite on paper
18 × 13 inches (45.7 × 33 cm)
1961.274

This beautifully delineated watercolor appeared as an illustration to Remington's self-penned article, "Indians as Irregular Cavalry," which appeared in *Harper's Weekly* on December 27, 1890. In the article, Remington argued strenuously for an end to the Indian Bureau's control over what he saw as the increasingly tangled, self-serving, and tragic course of Indian affairs. For Remington, the bureau and its corrupt, politically appointed agents were responsible for most of the armed conflicts of the past decade, not the Indians themselves. Moreover, he argued, the military was often made responsible for destroying a people who had "the entire sympathy of every soldier in the ranks." While Remington's case is somewhat biased and oversimplified, he nevertheless struck an important point with regard to the U.S. government's treatment of the Indians. "We are year after year oppressing a conquered people," he wrote, "until it is now assuming the magnitude of a crime."

By the time this was written, Remington enjoyed a lofty reputation as the leading artist-correspondent of the American West. His avid support of the U.S. military was well known and taken seriously in upper-level government circles, and his words on the plight of the Indians found ready, though scattered support. One of the solutions he urged was the incorporation of Indian warriors into the armed forces, and he pointed to the great success of the Indian scouting units under various commands. One of these was the Crow Scout Corps at Fort Custer, led by a young West Point graduate named Samuel C. Robertson. Remington noted that Roberston was a graduate of the French School of Cavalry, possessed a knowledge of sign language, and was endeavoring to learn the Crow tongue. With such able leadership, Remington reasoned, the Indian could serve as "the best possible light infantry cavalryman." He rode with Robertson's unit in the field, noting that they all wore leather leggings to protect themselves in the rough country—as Robertson does in this watercolor, which Remington produced during his visit to Fort Custer. The artist's unerring eye for detail and consummate skill in execution can be seen in the almost perfect rendering of the lithe, deeply muscled cavalry horse. At the end of his impassioned article for *Harper's Weekly*, Remington urged the U.S. government to take action. "Let us preserve the Native American race," he wrote, "which is following the buffalo into painted pictures and picture books."

Erwin E. Smith (1886–1947)

Four Cowpunchers Shooting Craps on a Saddle
Blanket in Roundup Camp, JA Ranch, Texas, 1908
Glass plate negative
5¼ × 7¼ inches (13.3 × 18.4 cm)
The Erwin E. Smith Collection of the Library of Congress
on deposit at the Amon Carter Museum, Fort Worth, Texas
LC.S6.079

In the early years of the twentieth century Erwin E. Smith began visiting historic ranches from West Texas to Arizona to photograph a vanishing way of life. Every summer for nearly a decade the Texas-born Smith, who had worked on ranches since childhood, carried his bedroll and equipment into the field to follow the trail drives of some of the most legendary outfits in the Southwest. For each ranch he visited, he obtained permission from its foreman to accompany the roundup wagon and cowpunchers. Because he had been a cowboy himself, Smith was determined to record every aspect of their daily existence before they disappeared from the range. "The cowboys lived the most picturesque and daring life the world has ever known and we will know," he wrote with characteristic fervor, "so it goes without saying that it is bound to live in the memory of those who know and love the West as it was in the palmy days." In the end, Smith created unforgettable images of cowboys and cattle that remain some of the finest photographs of the subject ever taken.

In the summer of 1908 Smith and his friend George Patullo, a Canadian-born writer who wanted to experience cowboy life on the open range, accompanied the roundup crews at the JA Ranch in the Texas Panhandle. This photograph, taken that summer, shows several cowhands engaged in one of Smith's typical scenes. Although Smith often deliberately posed his subjects in an effort to obtain the best composition and lighting conditions for his photographs, the scenes themselves were generally accurate in their detail. Here George Patullo is shown on the right; few, if any, authentic cowboys worked with their sleeves rolled up, unless it was for slaughtering. Patullo, being something of a greenhorn (as Smith himself was not), had to work hard to gain acceptance in the eyes of the JA Ranch's crusty wagon boss. At one point Patullo was given one of the meanest horses in the *remuda* to ride, an outlaw called Wasp's Nest; no doubt the wagon boss and his riders were disappointed when the feisty Canadian managed to stay on his mount. Through all of this, Erwin Smith managed to create captivating photographs of the roundup and its activities, including some stunning nocturnal images made by throwing handfuls of gunpowder into nearby campfires to get the necessary light.

Darius Kinsey (1871–1945)

Ten Horses Hauling 10-Foot in Diameter
Spruce Log on Skid Road in Washington, 1905

Gelatin silver print
10⅝ × 13⁵⁄₁₆ inches (27 × 33.8 cm)
P1991.11.1

Just as Erwin E. Smith was driven to depict the daily life of the open-range cowboy before that life vanished forever, Darius Kinsey was determined to capture the heroic period of logging in the primeval forests of Washington State. Arriving in 1889 in the frontier settlement of Snoqualmie with other members of his family, Kinsey almost immediately became involved in photography, establishing a successful portrait studio in the burgeoning lumbering center of Sedro-Wooley before moving it to Seattle in 1906. As early as 1895 Kinsey began photographing life and work in the logging camps, hauling his equipment into very difficult and isolated country to record the labors of the men who harvested the towering behemoths of the old-growth forests. Through great perseverance and extraordinary effort, Kinsey created a body of work that is far more than a simple chronicle of the logging industry at the turn of the century. Many of Kinsey's photographs have the elements of tonal richness, deft lighting, and compositional complexity that lift them to the level of fine art.

The quiet, easygoing Kinsey was well known in all the logging camps he visited, and the hard-bitten men willingly posed for him whenever he wished. He sold a number of his prints to the loggers themselves, for they had no trouble recognizing the quality of his work. In order to make a photograph like the one seen here, Kinsey sometimes stood on a giant stump—an average one could be eight to ten feet across—so he could set his tripod properly. He also created a special tripod more than fifteen feet high so he could get above the slash and brush that littered the logging area and have a better vantage point. This photograph was taken nearer to ground level, utilizing the enormous 11 × 14-inch "Empire State" camera that the photographer lugged into the backcountry for much of his work in this period—to say nothing of the onerous glass plates! After a day's shooting, Kinsey would send the negatives and individual orders for prints back to his studio in Seattle, where his wife would supervise the developing and printing by members of his family. The finished and mounted prints would then be returned to the photographer, who would hand-deliver them to the grateful recipients. Some of the men later recalled that the price of the photographs—fifty cents per print—was usually taken out of their wages by the logging company.

E. Irving Couse (1866–1936)

The Arrow Maker, ca. 1903

Watercolor and charcoal underdrawing on paper

26 × 40 inches (66 × 101.6 cm)

1961.387

In 1891 Couse visited his wife's family on their ranch in Klikitat County, Washington. It was a major change of scenery; he had just returned to America after five years of art study in France, including several seasons at the Académie Julian in Paris. The ranch, located on the eastern side of the Cascade Mountains not far from the Columbia River, afforded Couse the opportunity to observe members of the Klikitat, Yakima, Cayuse, and Umatilla tribes. He had received extensive training as a figure painter, and he quickly decided that the Indian was an ideal subject for his work. Although the following year Couse and his wife returned to Paris for further study, they returned to the ranch in 1896, where the artist spent two more years painting the Indians of the region. He then established a winter studio in New York, where he developed a reputation as one of the most important emerging artists of the period. It was there he met a fellow painter, Ernest Blumenschein, who told him of the wonderful landscape and Indian subject matter to be found in Taos, New Mexico.

Couse made his first visit to Taos in the summer of 1902, where he was immediately captivated by the light and color of the landscape and the picturesque Indians of Taos Pueblo. He met the painter Bert Phillips, who introduced him to Indians who were willing to pose for him. "The Indians are much better natured than the Coast Indians," Couse's wife wrote her family in Washington. "They are fine and don't object to posing at all so Mr. Couse feels all in clover." For Couse, trained in the academic tradition of classical figure painting, the Indians were artistic objects in and of themselves, and ethnographic accuracy was not a priority. He thus encouraged his models to wear as few articles of clothing as possible, as does the figure in this large watercolor, executed during the artist's second year in Taos. The model here is probably a Taos Indian named Juan Concha, who was one of the first individuals to pose for the artist. Even though Couse was familiar with many of the ethnographical writings of the time on American Indians, he was more concerned with the Indian as a picturesque subject—often isolated in time and place, as he is in this watercolor. "No one ever tried to paint the Indian in Couse's way before," noted a perceptive critic at the time. "No one has ever taken him quite so seriously from a purely artistic standpoint." Couse was very pleased with this watercolor, telling its first owner that he felt it was the best one he had ever done.

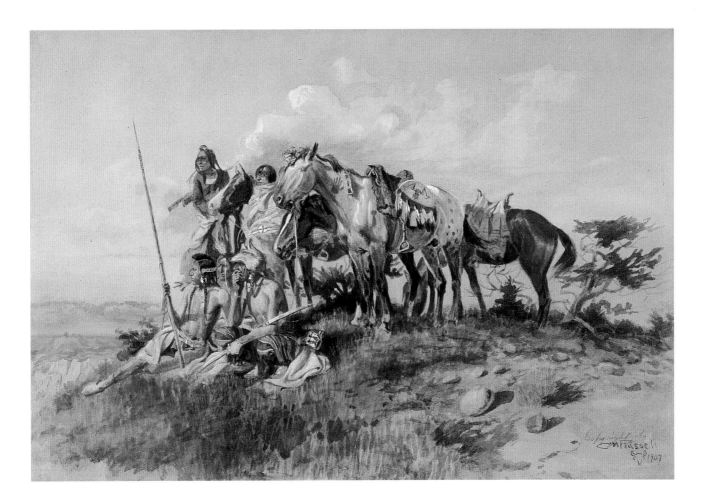

Charles M. Russell (1864–1926)

Watching for the Smoke Signal, 1907
Watercolor, gouache, and graphite underdrawing on paper
21 ⅞ × 31 ⅞ inches (55.6 × 81 cm)
1961.172

Although Russell did not have Couse's formal training or academic background, his depictions of Indians were more successful, partly because he developed a mature style of romantic realism based on a solid ethnographic foundation. Shortly after he came to Montana, he began observing the northern Plains tribes, particularly the Blackfeet and the Crow. He spoke with those who knew something of the history and culture of the tribes, and he eventually learned sign language so he could converse with many of them directly. He visited many camps and collected a number of artifacts for his studio collection. At a time when it was not very popular, he spoke up for the rights of dispossessed Indians; his growing reputation as Montana's most famous artist was instrumental in bringing some of these issues to wider attention. Many of his Indian friends visited him in his studio, and he frequently had them criticize his works in progress.

This watercolor, a typical example of Russell's romantic, yet sensitive view of the American Indian, depicts a Blackfoot war party on a piece of high ground scanning the surrounding landscape. Utilizing a tinted paper and vivid colors, Russell imparts a dreamy glow on the whole scene. His watercolor also supplies a

wealth of ethnographic detail. The braves are decorated for war and wear face paint as a form of spiritual "protection." The seated brave on the left wears a hairpiece common to the Blackfeet and Crow—a decorated strip around the middle of the head adorned with tassels of hair and adorned with paint or pieces of bright cloth. The coyote or wolf headdress on the man to his left may indicate that he is the scout of the party, for the animals were revered for their keen eyesight and ability at stealth. His wrist guard is an unusual detail, and the Pendleton blanket leggings—as well as the beadwork on his bow case—may be too late for the period the artist intended to evoke. The Appaloosa horse at the center is also painted and decorated for war as was the custom; the handprint on its neck generally means that the rider has "ridden over an enemy in battle," and the keyhole-shaped sign on its shoulder, known as a "rides-at-the-door" symbol, usually indicates a feat of great stealth and bravery in an enemy's camp. "This is the only real American," Russell wrote a friend who represented Montana in Congress. "He fought and died for his country—today he has no vote—no country—and is not a citizen—but history will not forget him."

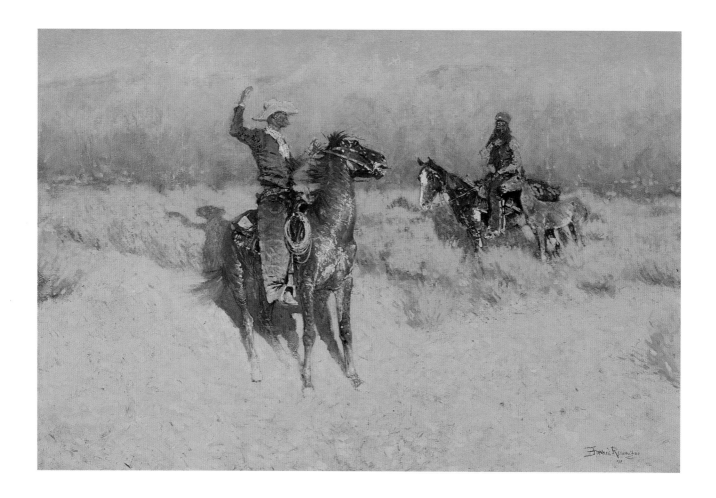

Frederic Remington (1861–1909)

The Long-Horn Cattle Sign, 1908
Oil on canvas
27⅛ × 40⅛ inches (68.9 × 101.9 cm)
1961.242

In the early years of the twentieth century, after he had achieved lasting fame as an artist-illustrator of western subjects, Remington's art began to undergo stylistic changes. He became more concerned with the technical aspects of painting itself, particularly the use and effects of color and light. One of the most immediate results of this interest was a series of nocturnal paintings, where Remington used limited color and bolder forms in his depictions of western subjects to evoke sensations of mood. When he exhibited these works the art critics were encouraging, and he began to explore the same effects with his daylight scenes. He began to remove many elements of detail from his works, concentrating instead on simplified forms and broad tonal qualities that suggested more generalized meaning. "Big art is the process of elimination," Remington wrote in 1903. "Cut down and out—do your hardest work outside the picture, and let your audience take away something to think about—to imagine." He was determined to improve his abilities as a painter. In February 1907, he noted that he had burned "every old canvas in [the] house today out in the snow. About 75—and there is nothing left but my landscape studies."

In that period, Remington befriended several of the most important American painters who were working in the impressionist style, and this late painting shows the effects of their influence. The western landscape in the painting—a molten swirl of mottled color and turbulent brushwork—becomes an expressive background for the two figures on horseback. The figures themselves seem to dissolve into unmodulated areas of tone and quick, short strokes of raw color. When he exhibited this work in December 1908, the critics applauded his new expressive power. "Mr. Remington has greatly improved," one of them noted. "His color is purer, more vibrant, more telling, and his figures are more in atmosphere." Even so, Remington was not willing to fully abandon his western subjects for works that embodied the notion of "art for art's sake." He knew the world he had painted as an artist-correspondent was long gone; in many ways, it existed only in his mind. In late paintings such as this—created the year before his untimely death at the age of 47—Remington's West had become a place of memory and imagination.

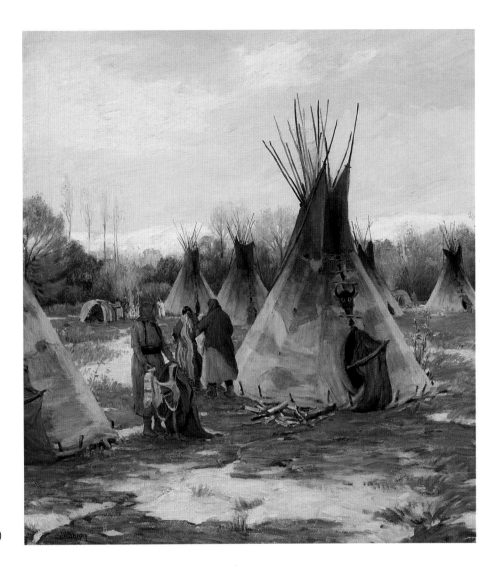

Joseph H. Sharp (1859–1953)

Squaw Winter, ca. 1910
Oil on canvas
30⅛ × 28 inches (76.5 × 71.7 cm)
1961.389

Although the Ohio-born Sharp is best known as one of the founding members of the Taos Society of Artists, his earlier work on the Crow reservation in southern Montana deserves to be better known. He first visited the Crow Agency in 1899 during a trip in which he explored a number of Plains Indian reservations, including those serving the Arapaho, Blackfeet, Cheyenne, Shoshone, and Lakota. As a trained portrait artist, Sharp was attracted to the Crow, a people noted for the beauty of their dress, as well as their horsemanship. Significantly, the Crow had not participated in the Plains uprisings against the U.S. Army; indeed, some members of the tribe had served with distinction as military scouts, as noted in the earlier comments under Frederic Remington's 1890 study of Lt. S.C. Robertson. Sharp produced a number of portrait studies of Crow individuals and quickly gained a measure of success when he sold a group of eleven of them to the Smithsonian Institution. Shortly after that sale, he exhibited a group of them at the *Pan-American Exposition* in Buffalo, where he met his most important patron, Phoebe Hearst, who purchased seventy-nine works with the promise to

acquire more on a yearly basis. By 1903, Sharp had resigned his job as a teacher in Cincinnati to live and work at the Crow reservation full-time.

As an official guest of the Crow Agency, Sharp built a small cabin and studio in 1905 that he affectionately named the "Absarokee Hut," after the name the Crow called themselves. Accompanied by his wife, the artist settled into a year-round existence that he found very much to his liking. He told visitors that he preferred to paint during the winter months, when color tonalities were more subdued and patches of snow reflected a variety of shades, as they do in this everyday scene in a Crow camp. From a practical standpoint, Sharp also noted that it was much easier to find models during the winter months. He employed a sheepherder's wagon as a traveling studio, hauling it to different locations until, he laconically noted, "cold froze the paint." In the background of this colorful wintry scene, women can be seen preparing sweat lodges and fires for heating the stones that will provide the necessary steam for the participants. Once they were finished, they ran to a nearby stream for an icy plunge.

Laura Gilpin (1891–1979)

Sunrise on the Desert, 1921

Platinum print
7¼ × 9¼ inches (18.4 × 23.5 cm)
Copyright © 1979, Amon Carter Museum, Fort Worth, Texas
Gift of Laura Gilpin
P1979.95.59

After the turn of the century, photography became increasingly recognized as a form of fine art. Laura Gilpin, born and raised in Colorado, studied photography at the Clarence H. White School in New York, where the aesthetic properties of the medium were taken seriously. "Modern photography has brought light under control and made it as truly art material as pigment or clay," proclaimed the school's brochure. "The photographer has demonstrated that his work need not be mechanical imitation. He can control the quality of his lines, the massing of his tones and the harmony of his gradations." Gilpin was an avid, hardworking student and learned a great deal under White's influential tutelage. Returning to Colorado in 1918, she discovered a subject she would actively pursue for the rest of her long and fruitful career: the western landscape. By 1921, she had produced enough work to hold a substantial one-woman exhibition of sixty-one landscape photographs at the Broadmoor Art Academy. The exhibition traveled on to the Museum of New Mexico and the Denver Public Library, where her work was praised for its "intelligence in light and dark arrangement" and "control of line and form."

Gilpin was attracted to the expansive skies, sweeping prairies, and broadly rising mountains of southern Colorado and New Mexico. This evocative photograph utilizes a clear sense of the abstract qualities of light and tone to convey the grand vistas of her native West. The photograph's beauty and appeal is due in part to Gilpin's masterful use of the platinum printing process, a method that yielded a range of velvety blacks and richly varied tones. The process was demanding and difficult to master, but Gilpin preferred the soft beauty of platinum prints for the visual effects she wished to present. She was fascinated with the idea of a "spiritual atmosphere" in a given landscape, and at this point in her career she employed soft-focus lenses to help her achieve her ends. "We have a superb landscape that can hardly be equaled," she told a newspaper reporter in the period. "Is there a finer way in which we can show our appreciation of Colorado than by helping to perpetuate its beauties on the walls of our future museums and homes?" During a career that was to last almost sixty years more, Gilpin explored the southwestern landscape not only for its inherent beauty, but as an expressive backdrop for the native peoples that lived there.

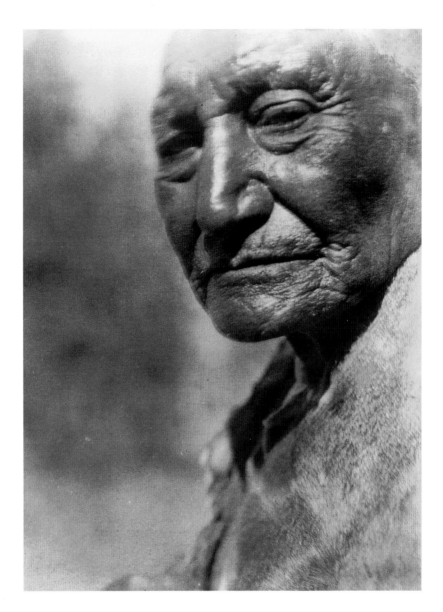

Edward S. Curtis (1868–1952)

An Aged Paviotso of Pyramid Lake, 1924

Photogravure on tissue
15¼ × 11⅜ inches (38.7 × 28.9 cm)
P1977.1.537

Curtis led an extraordinary life of single-minded devotion to the goal of photographing members of all the significant Indian tribes of the United States. The Seattle-based photographer began this monumental task shortly after the turn of the century, and he continued his work with dogged determination for close to thirty years. Along the way he gained support from many of the most famous figures of his age, and he received help from a number of dedicated family members and assistants. The result was a masterwork unique to the history of photography—twenty volumes of text, illustrated with more than fifteen hundred images, published between 1907 and 1930 under the straightforward title, *The North American Indian.* In addition to this, Curtis also published twenty portfolios containing over seven hundred photogravures—a laborious and painstaking process that involved the careful transferal of each of his photographic images onto copper plates for printing on a flatbed press. The results were photomechanical reproductions of unusual subtlety and beauty.

This sensitive and boldly composed portrait is a photogravure on tissue from Volume 15 of *The North American*

Indian, published in 1924. Much of the text and most of the photographs for this volume seem to have been taken some years prior to its eventual publication. We know that Curtis and his daughter Florence spent the summer of 1922 on an intensive working trip through northern California and southern Oregon, and it's possible that they could have traveled to the reservation at Pyramid Lake in western Nevada at the same time. At the turn of the century the name Paviotso was assigned to the Shoshonean tribes of the area, but today they are known as the Paiutes. Years after the publication of his work, Curtis was faulted by anthropologists and others because he "manipulated" his subjects; that is, he created artificial poses and settings for many of his images. Moreover, like others of his time he spoke of the Indian tribes as a "vanishing race," when in fact they had never vanished at all. Still, for the most part his photographs are sensitive, even powerful portrayals of diverse peoples. The face of this aged Paviotso alone speaks volumes about the dignity of human existence, requiring no other props to convey its message.

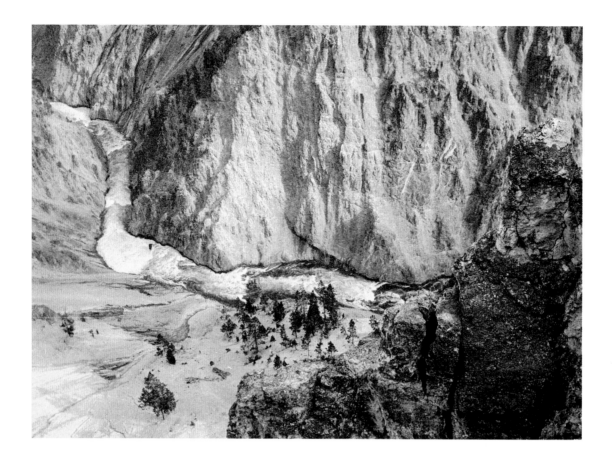

Louise Deshong Woodbridge (1848–1925)

Yellowstone "Grand View," ca. 1912

Platinum print
3 7⁄16 × 4 11⁄16 inches (8.7 × 11.9 cm)
P1981.70

In the years prior to the turn of this century, a small number of American photographers began to emphasize pictorial elements such as light, composition, and theme to convey the primary message in a photograph. For these artists, a landscape photograph could be much more than a simple documentary record; it could become an artistic evocation of nature itself. Along with these seminal developments, the popularity of photography burgeoned in the late 1800s. Photographic societies and clubs were established in cities across the United States, and more and more women were drawn into the practice of the medium. Louise Woodbridge was a lifelong resident and prominent society figure in Chester, Pennsylvania, who learned to photograph through the encouragement of several friends who were members of the Photographic Society of Philadelphia. She became primarily interested in landscape, and her works were exhibited in Philadelphia and at the *World's Colombian Exposition* in 1893. She traveled widely and became an active supporter of several Philadelphia institutions devoted to the study of science and art.

Like many of her photographic contemporaries, Woodbridge printed her works on platinum paper, an expensive material that enabled her to achieve a wonderfully broad range of rich tones and varied textures. Such elements are apparent in her masterful depiction of the Grand Canyon of the Yellowstone, taken on a trip to the region some time after her sixtieth year. The vantage point of this scene is hardly conventional. Prior to this, most photographers and painters viewed the river and its canyon in a much more straightforward way, generally looking upstream to include the Upper or Lower Falls. Woodbridge, on the other hand, adopts a precarious view off the upper edge of the canyon wall looking down to the river below. What results is a flattened view that almost causes the photograph to appear as an arrangement of abstract forms. There is a tenuous sense of scale, although the scattered trees provide a partial reference point. Such a vantage point is decidedly modern, and Woodbridge effectively took a familiar view of a western landmark and stood it on its head. As her title implies, it is surely a "grand" view in the sense that the power of the image derives from the artist's ability to evoke the dizzying visual complexity of the canyon beyond its outward appearance.

Stuart Davis (1892–1964)

New Mexican Landscape, 1923
Oil on canvas
32 × 40¼ inches (81.3 × 102.2 cm)
1972.49

For an artist like Davis, the western landscape offered an opportunity to further assert the conviction that the subject matter of a painting is less important than its formal qualities. In the summer of 1923 he journeyed to Santa Fe, anticipating that he would find there a place as inspirational as the Massachusetts fishing town of Gloucester, where he generally spent part of each year. Davis was one of the few American artists in this period who fully understood the new modernist theories then emanating from Europe, and he worked steadily to develop a methodical style derived from those precepts. A year before his arrival in New Mexico, he wrote in his journal that mere subject matter was no longer important to him. "Pure decoration is what I want," he declared. "Away from realism in the sense of recording character. The powerful basis of visual beauty is line and color." He defined painting in that period as the act of creating a group of forms that were related to one another by color, texture, and line, which together achieved an "equilibrium," or balance at the center of the canvas. For Davis, this pictorial language allowed him to achieve a "synthetic reality without great difficulty because you're not trying to recreate life, only trying to make a painting."

As it turned out, the power of the New Mexico landscape proved to be something of an obstacle for Davis. Although he professed disappointment with the area, he seems to have struggled with what he later termed the "dominating" actuality of the landscape itself. Although this vivid and evocative painting depicts a typical New Mexican vista of adobe houses, arid hills dotted with sage, and shadowy mountains rising in the distance, it becomes more of a visual essay in line, color, and texture. As if to underscore this message, Davis enframes the entire view with concentric borders of varying shades of gray. The scene in the painting thus appears to be viewed through a window in the artist's studio—or from the interior of his artistic self. "One is stimulated by the visual contemplation of certain natural objects in the desire to duplicate the sensation of pleasure by the process of painting," Davis wrote just before his trip to New Mexico. "A painting is a collection or complex of colored tones of definite shape and size, that is all. Everything that is expressed through the medium of painting must live through these properties of size, shape, and color."

Anne W. Brigman (1869–1950)

Flame, 1927
Gelatin silver print
9½ × 7 11⁄16 inches (24.1 × 19.5 cm)
P1984.27

During the 1920s the modernist idiom in photography included a search for unconventional subjects, a preference for close-ups or unusual angles, sharper definition, and careful attention to the effects of light. At the same time, many photographers became involved with advertising work, and many more were influenced by the images that were subsequently produced—images that generally adopted the modernist vocabulary. The year she created this arresting close-up of the stalks of an agave plant, Brigman had been active on the West Coast as a photographer for more than twenty-five years. Her earlier work, consisting mostly of idealized, soft-focus evocations of nudes in outdoor settings, earned praise from Alfred Stieglitz and allowed her entry into the exclusive ranks of the Photo-Secession group—one of the few western photographers to be so honored. Brigman loved the outdoors, and nearly every year she packed her equipment for a lengthy trip into California's Sierra Nevada Mountains, often to a favorite locale—Desolation Valley in the high country. "It is primeval; it is austere; it is forbidding; it is sinister," she wrote somewhat melodramatically, "and yet, withal it is most radiant and beautiful."

Brigman's rather abstract study of an agave plant was a departure from her previous figural work, and it may have been due to the company she was keeping in the period. She knew Imogen Cunningham and Edward Weston, two of the most important photographers working in California at that time. Both of these photographers were producing elegant, complex close-up depictions of plants and other ordinary objects, and it seems likely that Brigman was influenced to move in a modernist direction by the work of these two artists. Even so, Brigman's older pictorialist style is still evident in the allegorical title she assigned to this work—a title that suggests something other than what is straightforwardly expressed. The stalks of the agave are presented at close range, with no hint as to their context or surroundings. Light delineates the individual stalks, often bringing the thorns that grow along their edges into sharp relief. At the same time, there is a softness to the image that separates it from the harsher, more sharply defined images by her compatriot Weston. And like Cunningham, Brigman seemed to waver between the analytical purity of the modernist vision and the dreamy, romantic realm of the pictorialists.

Georgia O'Keeffe (1887–1986)

Dark Mesa and Pink Sky, 1930
Oil on canvas
16¼ × 30⅜ inches (41.3 × 77.2 cm)
1965.80

In the summer of 1929, O'Keeffe made her first visit to New Mexico at the invitation of a friend, Mabel Dodge Luhan. Arriving in Taos, she stayed in the house that had been occupied by the English writer D.H. Lawrence. Almost immediately, the artist was captivated by the southwestern landscape. "The summer I lived in Taos I sometimes rode out into the eastern hills late in the afternoon with the sun at my back," O'Keeffe later recalled. "No one else seemed to go there." She described her fascination with the ancient hills, eroded by thousands of years of wind and rain; she was attracted to their complexity— "so beautifully soft, so difficult"—painting them again and again. "When I was returning east I was bothered about my work," O'Keeffe wrote many years later. "The country had been so wonderful that by comparison what I had done with it looked very poor to me—although I knew it had been one of my best painting years." The New Mexico landscape is indeed a transforming presence, as D.H. Lawrence noted after his own sojourn there. "It had a splendid silent terror, and a vast far and wide magnificence which made it way beyond mere aesthetic appreciation," he wrote. "Never is the light more pure and overweening than there, arching with a royalty almost cruel over the hollow, uptilted world. . . . Just day itself is tremendous there."

In 1930 O'Keeffe returned to Taos, spending part of the summer exploring the hilly desert country in the Rio Grande Valley to the south. She isolated herself in the small town of Alcade, where she attempted to capture the smoothly eroded contours and multicolored hues of the surrounding landscape. She later recalled that she struggled to express "the unexplainable thing in nature that makes me feel the world is big far beyond my understanding—to understand maybe by trying to put it into form. To find the feeling of infinity on the horizon line or just over the next hill." Not surprisingly, the landforms of *Dark Mesa and Pink Sky* are reduced to elemental shapes that seem to evoke the underlying power of nature itself. While the strongly expressive colors represent the varying geologic strata of the actual landscape, the high contrast between the dark forms of the mesa and the bright area of sky suggests the brilliance of the New Mexico light. "It is surprising to me to see how many people separate the objective from the abstract," O'Keeffe wrote in later years. "Objective painting is not good painting unless it is good in the abstract sense. A hill or tree cannot make a good painting just because it is a hill or a tree. It is lines and colors put together so that they say something. For me that is the very basis of painting."

John Marin (1870–1953)

Taos Canyon, New Mexico, 1930

Watercolor and charcoal on paper

15½ × 21 inches (39.4 × 53.3 cm)

1965.5

Georgia O'Keeffe was one of those who encouraged Marin, a friend and fellow artist whose work was also represented by the photographer and art dealer Alfred Stieglitz, to visit the alluring Taos region in the summers of 1929 and 1930. Marin was accustomed to painting in places like the picturesque White Mountains of New Hampshire or along the rocky coast of Maine, so New Mexico represented a real change. Like many artists before him, Marin was immediately drawn to the piercing natural light that revealed new things to him about landscape. Over the two summers, he worked furiously outdoors on his portable easel and painted more than one hundred watercolors—each of them, for the most part, executed at a single sitting. During his initial visit he painted what he saw in a rather straightforward manner. "Particularly where the country is new I can't take any liberties with it at the start," he told an artist friend, "so I look and search and paint what I see." By the following summer, when he returned to the same area to paint anew, Marin seemed to find his style. He began translating the landscape elements into more abstract planes and lines, combined or set apart by strong areas of expressive color. Like his

artistic mentor, the French painter Paul Cézanne, Marin realized that only by implementing new forms could traditional views of nature—including those of the West—be given fresh meaning.

Those who were fortunate enough to see Marin work never forgot the experience, for he approached his art with a consuming passion. On some occasions he was known to paint excitedly with both hands, and his writings comprised chains of poetic statements linked by dashes, as if the artist was in a breathless rush to get his ideas on paper. In this watercolor, the New Mexico landscape seems wholly animated and alive through its vivid colors and angular forms. Even the sky is transposed into a series of shifting planes, one on top of the other. "The East looks screened in / The West is a memory that we are constantly talking about," Marin wrote in typical fashion to a friend that same year. "The One who made this country this big level seeming desert table land cut out slices. They are the canyons. Then here and there he put mountains atop. A standing here you can see six or seven thunderstorms at one time. . . . Sunset seems to embrace the earth."

Marsden Hartley (1877–1943)

Earth Cooling, Mexico, 1932
Oil on board
24½ × 33½ inches (62.6 × 85.1 cm)
1967.191

Hartley was a restless artist, traveling to many areas in the United States and Europe to study and paint. His work reflected several modernist styles, but it was also work to be understood on its own terms. Hartley visited the Taos and Santa Fe regions as early as 1918–19, and subsequently spent the better part of the next decade in Europe. In 1931, he was delighted to learn that he was the recipient of a Guggenheim Fellowship to travel and paint in Mexico. The resulting trip lasted a little more than a year and left the artist physically and emotionally drained. "Mexico is as oblique a place as can be imagined," he wrote at the end of that year. "It is a place where all the colors and the forms are at variance with each other—nothing becomes precise, neither form, design, nor color." After a period in Mexico City to study Aztec and Mayan art, Hartley spent most of his time in Cuernavaca, absorbed in the study of spiritualism. The paintings he created during his stay there, including the one seen here, are notable for their heavy, brooding forms and vivid, molten colors. But though Hartley was deeply affected by the raw power of the landscape, with its "smoldering volcanoes" and "the most amazing light [the] eye has ever encountered," these were landscapes that owed more to what lay inside the artist's mind than outside in the world at large.

Part of Hartley's deep emotional response to the landscape was due to tragedy. In Mexico he had renewed a friendship with the poet Hart Crane, who had also come to the country on a Guggenheim Fellowship. Like Hartley, Crane was interested in new forms in art, and he was also romantic and emotional in attitude. Two years earlier, Crane had published to mixed reviews an epic poem on America titled *The Bridge;* in Mexico, he struggled with self-doubt as Hartley tried to help him. These efforts were in vain, for Crane committed suicide shortly thereafter. Heartbroken, Hartley transferred his feelings to the dark imagery of his paintings. In the end, the Mexican experience proved too oppressive for the sensitive artist. "I think of Mexico as something lived through vividly—for it was a place that devitalized my energies—the one place I shall always think of as wrong for me," he wrote shortly after his stay. Thus for Hartley, the landscapes of Mexico and the western United States were not only powerful and evocative in their own right, but served as dark mirrors of his troubled soul.

Further Reading about the Western Collection

Alfred Jacob Miller: Watercolors of the American West, by Joan Carpenter Troccoli (Tulsa: Gilcrease Museum, 1990).

The Artist Was a Young Man: The Life Story of Peter Rindisbacher, by Alvin M. Josephy, Jr. (Fort Worth: Amon Carter Museum, 1970).

Artists and Illustrators of the Old West, 1850–1900, by Robert Taft (New York: Charles Scribner's Sons, 1953).

The Beat of the Drum and the Whoop of the Dance: A Study of the Life and Work of Joseph Henry Sharp, by Forrest Fenn (Santa Fe: Fenn Publishing Company, 1983).

Carleton E. Watkins: Photographer of the American West, by Peter E. Palmquist (Albuquerque: The University of New Mexico Press and the Amon Carter Museum, 1983).

Charles M. Russell: The Life and Legend of America's Cowboy Artist, by John Taliaferro (Boston: Little, Brown and Company, 1996).

Charles M. Russell: Masterpieces from the Amon Carter Museum, by Rick Stewart (Fort Worth: Amon Carter Museum, 1992).

Eanger Irving Couse: Image Maker for America, by Virginia Couse Leavitt (Albuquerque: The Albuquerque Museum, 1991).

Edward S. Curtis: The Life and Times of a Shadow Catcher, by Barbara A. Davis (San Francisco: Chronicle Books, 1985).

Era of Exploration: The Rise of Landscape Photography in the American West, by Weston J. Naef (Buffalo and New York: The Albright-Knox Art Gallery and the Metropolitan Museum of Art, 1975).

The First Hundred Years of Painting in California, 1775–1875, by Jeanne Skinner Van Nostrand (San Francisco: John Howell Books, 1980).

Frederic Remington: A Biography, by Peggy and Harold Samuels (Garden City, New York: Doubleday & Company, 1986).

Frederic Remington: Masterpieces from the Amon Carter Museum, by Rick Stewart (Fort Worth: Amon Carter Museum, 1992).

Georgia O'Keeffe, by Charles C. Eldredge (New York: Harry N. Abrams, Inc., and the National Museum of American Art, 1991).

German Artist on the Texas Frontier: Friedrich Richard Petri, by William W. Newcomb, Jr. (Austin: University of Texas Press, 1978).

Imagining the Open Range: Erwin E. Smith, Cowboy Photographer, by B. Byron Price (Fort Worth: Amon Carter Museum, 1998).

John Marin: A Stylistic Analysis and Catalogue Raisonné, by Sheldon Reich (Tucson: University of Arizona Press, 1970).

Kinsey Photographer: A Half Century of Negatives by Darius and Tabitha May Kinsey, by Dave Bohn and Rodolfo Petschek (San Francisco: Prism Editions, 1978).

The Last Buffalo: The Story of Frederick Arthur Verner, Painter of the Canadian West, by Joan Murray (Toronto: The Pagurian Press, 1984).

Laura Gilpin: An Enduring Grace, by Martha A. Sandweiss (Fort Worth: Amon Carter Museum, 1986).

Marsden Hartley, by Barbara Haskell (New York: Whitney Museum of American Art and New York University Press, 1980).

Modernist Painting in New Mexico, 1913–1935, by Sharyn Udall (Albuquerque: University of New Mexico Press, 1984).

The North American Indians in Early Photographs, by Paula Richardson Fleming and Judith Luskey (New York: Harper & Row Publishers, 1986).

Photographing the Frontier, by Dorothy and Thomas Hoobler (New York: G.P. Putnam's Sons, 1980).

Plains Indian Art from Fort Marion, by Karen Daniels Peterson (Norman: University of Oklahoma Press, 1971).

A Poetic Vision: The Photographs of Anne Brigman, by Susan Ehrens (Santa Barbara: The Santa Barbara Museum of Art, 1995).

Richard H. Kern: Expeditionary Artist to the Far Southwest, 1848–1853, by David J. Weber (Albuquerque: The University of New Mexico Press and the Amon Carter Museum, 1985).

The Rocky Mountains: A Vision for Artists in the Nineteenth Century, by Patricia Trenton and Peter H. Hassrick (Norman: University of Oklahoma Press and the Buffalo Bill Historical Center, 1983).

The San Antonio Missions: Edward Everett and the American Occupation, 1847, by Richard Eighme Ahlborn (Fort Worth: Amon Carter Museum, 1985).

Stuart Davis: American Painter, by Lowry Stokes Sims (New York: The Metropolitan Museum of Art and Harry N. Abrams, Inc., 1991).

American Frontiers: The Photographs of Timothy H. O'Sullivan, 1867–1874, by Joel Snyder (Millerton: Aperture, 1981).

Views of Texas, 1852–1856: Watercolors by Sarah Ann Lillie Hardinge, by Ron Tyler (Fort Worth: Amon Carter Museum, 1988).

The West as America: Reinterpreting Images of the American Frontier, 1820–1920, by William H. Treuttner and others (Washington: Smithsonian Institution Press, 1991).

Wild River, Timeless Canyons: Balduin Möllhausen's Watercolors of the Colorado, by Ben W. Huseman (Fort Worth: Amon Carter Museum, 1995).